IMAGES
of America

MATHEWS
COUNTY

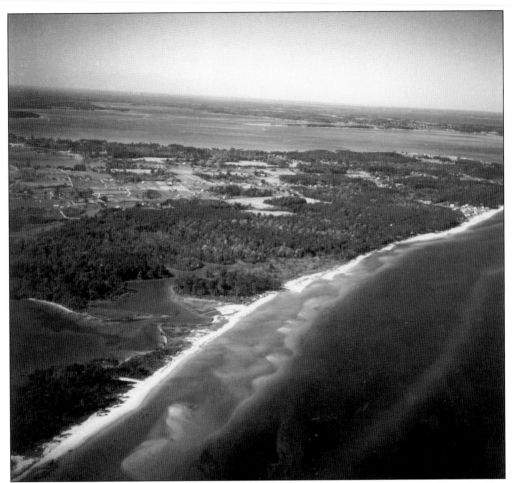

Mathews County is a neck of coastal earth that falls from a narrow rim to become flounder flat, nearly level with the water that surrounds it. One-half of Mathews is 10 feet above sea level or less. The Piankatank River on the north and the Chesapeake Bay on the east make up two sides. The Mobjack Bay holds its southwestern shore and sends the North River back toward the Piankatank, where the less than 88-square-mile county reaches up again to its highest elevation: the ridgeline that connects it to Gloucester, its parent. Mathews boasts hundreds of miles of waterfront property. Waterfront has made Mathews popular with shipbuilders and waterman, residents and vacationers. (Photograph by Walter G. Becknell; courtesy of the Gwynn's Island Museum.)

ON THE COVER: George A. Philpotts's wharf on the Mobjack Bay was a center of early-20th-century industry in Mathews County. Emmett Machen's boats, the *Canary Bird* (left) and the *Elizabeth Farrow*, were used for oystering. Machen would buy seed oysters from the James River and take them to the Mobjack Bay to "set," or attach themselves to shells or other hard material. In about two years, the oysters would be market size. They would be dredged and sold to shuckers on the Eastern Shore for transport by rail or shucked and iced for transport by steamboats to Northern markets. Crab pickers from Mathews stand on the wharf for the photograph. Crabmeat was picked and stored in cans and barrels of ice and readied for sale. Philpotts also ground starfish for fertilizer and corn and wheat for livestock feed. The wharf was heavily damaged in the August storm of 1933, but it was rebuilt. The oyster business declined through the 1950s, and the wharf deteriorated. (Courtesy of Wilson Davis.)

IMAGES
of America

MATHEWS
COUNTY

Sara E. Lewis

ARCADIA
PUBLISHING

Published by Arcadia Publishing
Charleston SC, Chicago IL, Portsmouth NH, San Francisco CA

Printed in the United States of America

Library of Congress Catalog Card Number: 2007930070

For all general information contact Arcadia Publishing at:
Telephone 843-853-2070
Fax 843-853-0044
E-mail sales@arcadiapublishing.com
For customer service and orders:
Toll-Free 1-888-313-2665

Visit us on the Internet at www.arcadiapublishing.com

This book is dedicated to the fine men, women, and children of Mathews.
"The finest product of Mathews is not ships nor fish, but its
superb manhood. Those who have been reared there are almost
without exception honest, upright, substantial and trustworthy
men, who make valuable citizens wherever they go."

—History and Progress, Mathews County, Virginia, page 5

CONTENTS

Acknowledgments 6

Introduction 7

1. Early History 9

2. The Kingston Parish Years 13

3. From the American Revolution to the Civil War 21

4. Happy Homes and Fertile Farms 31

5. Life on Smiling Waters 53

6. Centers of Community Life 83

7. A River Place 117

8. Challenges Ahead 125

ACKNOWLEDGMENTS

This book was compiled with help from many people who share an interest in the past and future of Mathews County. I thank the following individuals for their enthusiastic help and sharing of photographs and content information: Ralph Anderton; William L. Brockner; Catherine C. Brooks, author; E. Eugene Callis III, clerk, Mathews County; Wilson Davis; Bette Dillehay, director, Mathews Memorial Library; Helen Forrest, Antioch Baptist Church; Richard Hollerith Jr.; C. C. Hollerith Lefferts; Woody, Nancy, and Ron James; Nancy Lindgren, Katherine Miller Hendrick, and Peter Wrike, Mathews Maritime Foundation; E. Randolph McFarland, U.S. Geological Survey; Terry Pletcher, president, Mathews County Historical Society; Smith family members Jimmy Smith, Lynda Smith Greve, and Joice Smith Davis; Earl L. Soles Jr.; Diana Hudgins Swenson; Bob Tanner; Jean Tanner, director, Gwynn's Island Museum; and Elsa Cooke Verbyla, editor, *Gloucester-Mathews Gazette-Journal* (Tidewater Newspapers, Inc.).

Special thanks go to my family for their interest, help, support, and love: Frank Raymond Lewis Jr., my father, born and reared in Hudgins; Mary Belle Jones Lewis, my mother, born and reared in North; Susan Lewis Dutton, my sister, a Gloucester native who spent childhood years with me visiting Mathews relatives and friends; Tommy Dutton, my brother-in-law, Mathews High School teacher, coach, and guidance counselor; Kenneth Schmidt, my husband; Elizabeth Flanary, my daughter; and Lewis Flanary, my son.

I thank Jean Patterson for the use of her Gwynn's Island home, where I enjoyed overnight stays while working on this book. I thank Courtney Hutton, Jami Sheppard, and Lauren Bobier of Arcadia Publishing for their assistance.

I have sought and taken advice from many and hope that errors are few. I welcome comments about the inevitable inaccuracies. They may be sent to my attention at the publisher's address.

This brief book is not intended to be a definitive history. Those who use it as a research tool should also consult other books about Mathews. In addition, they should look for original lists, letters, account books, and other documentation that continually challenge and enlighten assumptions about the past.

INTRODUCTION

The citizens of Mathews County, Virginia, have preserved its unique, small-town character into the first decade of the 21st century. At first glance, the scattering of mostly frame houses along country roads, wide-open marsh views, and abundance of century-old churches lend the appearance of yesteryear. The lack of traffic lights, malls, and cookie-cutter developments gives Mathews the look of a land that time forgot.

But looks can fool. Mathews is a community of large extended families and willfully connected people who have managed the rush of recent times. The result is a place with many charms: a place that has been dubbed the pearl of the Chesapeake.

Mathews is located on the northern claw of Virginia's Middle Peninsula, the southern half being Gloucester County. Together they hold the Mobjack Bay, which opens onto the Chesapeake. It is partly due to this location—on the way to nowhere but Mathews—that the will to overdevelop has been kept at arm's length. Mathews is a place that is purposefully found. Company comes to see family; seek the quiet of a cottage; fish, sail, or kayak on saltwater tides; and live consciously.

Its watertight location is the very reason Mathews appealed to Native American as well as pre-industrial settlers, shipbuilders, farmers, and watermen. The rivers within and the Chesapeake Bay beckoned them with food for the taking and paths for travel and commerce. The surnames of current residents mark them as descendants of Mathews's pioneers.

This volume has been compiled for "been-heres," "come-heres," "come-backs," and visitors who love the special history of Mathews. This broad-brush story of special places and people is a nostalgic reflection and a window on the quality of life in past times.

The task of telling the earliest history of the Mathews area using photographs is indirect and brief. Arrowheads, bone, pottery, and fossils serve as reminders of life long before the age of photography. No photographs exist of the large mammals that once roamed Mathews's swampy land. We have arrowheads but no photographs of Native American clans. We have drawings but no photographs of Mathews's first English settlers, who discovered this place to be good and convenient.

So this volume begins with a nod to the deep past and to the peoples whose ancestors lived here for thousands of years before Westerners came. Next photographs in this book will suggest the earliest settlement by Englishmen and Africans. Today's Mathews was Gloucester's Kingston Parish until after the American Revolution. It was scantly populated but prosperous for shipbuilders, sea captains, and landholders. Like most of Tidewater Virginia, the population was probably about half of European stock and half of African or African American lineage.

In 1790, Mathews's history as a political entity began. In that year, Brig. Gen. Thomas Mathews, Revolutionary War veteran and Speaker of the House of Delegates of the General Assembly of Virginia, introduced a resolution for the division of Gloucester and the formation of a new county. Beginning in 1791, land that developed into Colonial Gloucester's Kingston Parish (as

well as a small portion of Ware Parish) became Mathews, a county in its own right, named to honor the Speaker.

The fortunes of the descendants of early residents changed after the American Revolution. Many Gwynn's Island families left after the American Revolution because of the Dunmore's abuse of their property. Others in the county were economically distressed because of their support of the war. For those who stayed, it was a long journey to Gloucester Court House by foot, on horseback, or by water. The partition was necessary to meet the needs for easier access to courts and county government services.

But shipbuilding was still the county's key occupation. Perhaps it was shipbuilders who had the ear of the Speaker, that played a role in separating the county for economically expedient reasons. The Mathews County seal, adopted on February 11, 1793, symbolizes the importance of the shipbuilding industry in the county.

A chapter illuminates the Colonial and early-19th-century history of Mathews up to the Civil War. Photographs provide a window to thinking about the robust and awe-inspiring work of sailing ship construction. Shipbuilding continued until steamboats and trucks replaced the need for elegant sailing ships.

Although inventors had studied optics and devised cameras earlier, the age of photography is generally marked by the appearance of daguerreotype photographs in early-19th-century France. Well-known American photographs document the Civil War, when great strides were made in the technology. George Eastman exploited the development of roll film and cameras became more common by the end of the 1800s.

In Mathews, vacationer and resident Herman Hollerith Sr. took some of the earliest photographs of Mathews. Local sites were often backdrops to his children's play. His son, part-time resident Herman Hollerith Jr., photographed Mathews more extensively. His photographs of docks, boats, and waterfront occupations have been published frequently, and many are now the property of the Chesapeake Bay Maritime Museum (CBMM), the Mariners' Museum, and other institutions. The Mathews County Land Conservancy at Williams Wharf holds copies of Hollerith's images, which were made available for this book.

Agricultural pursuits and seafood harvesting were primary occupations after the decline of shipbuilding. Many photographs inspire us to recall what it was like to live off the land and sea, gathering potatoes and tomatoes, fish and clams. Like nearby Gloucester, Mathews is known for daffodils, first shipped by steamboat, then by refrigerated truck through the mid-20th century. Mathews's families had been self-sufficient of necessity until electricity and cars permitted new occupations and mobility.

Mathews has been called the land of post offices and churches, where citizens have gathered and greeted. Schoolchildren posed for photographs, and families and organizations came together for church and special occasions. In a selection of such photographs, we see the familiar faces of those whose spirits linger.

The seagoing legacy continued as men went to sea on passenger liners and cargo ships. During two world wars, a network of Mathews's men could be found in command of ships in ports far from home. Though watermen still bring in succulent seafood, the days of abundance are gone. The purr of a deadrise invites those who cherish the Chesapeake region to remember a day when fishing and boating were far more than recreation.

Mathews's waterfront views invite memories of bygone days that enchant natives and visitors alike. Many photographs invite us to look through the peaceful marsh and pine trees on Mathews's edges to reflect on the past as seen in places and faces. A small county that is self-aware, straightforward, and singular shines through. Mathews holds us close, provides a lesson in living, and inspires reflection.

One

EARLY HISTORY

Mathews County was founded in 1791, but English claims on the land began about 180 years earlier. Before the English settled, accompanied by indentured servants and slaves of African descent, Powhatan Indians of the Piankatank tribe hunted for food and lived in villages there. But they were not the first human settlers. Native American artifacts have been found that predate them. The first prehistoric humans left behind artifacts that date as far back as 10,000 years, possibly more. Before humans, large animals such as mastodons and whales traversed this land and the sea that alternately covered and surrounded it.

About 10,000 years ago, the ice sheets that had formed during the last Ice Age began to melt rapidly, causing the sea level to rise and flood the present-day North American east coast continental shelf and river valleys. One of the flooded valleys became the Chesapeake Bay.

It is interesting to note that the rivers of the Chesapeake region converge at a location directly over a buried crater that was made when an asteroid or comet collided with the earth about 35 million years ago. The Chesapeake Bay bollide penetrated several hundred feet of ocean water and thousands of feet of sediment. The impact created an enormous crater, centered near present-day Cape Charles. It sent up chunks of granite as well as pieces of sedimentary rock and created a crater 56 miles across.

Within a few days of the cataclysm, everything settled again and the ground was covered with broken rock. Through the ensuing years, sediment covered the crater. The loose rock compacted, and with each subsequent Ice Age, the layers consolidated. As the Virginia river valleys converged over the compacted debris and the sea level rose, a long-lasting depression was created that became the Chesapeake Bay. The land over the crater, including the area we call Mathews, continues to compact and subside faster than the land around it. The Chesapeake impact crater region is the location of the highest relative sea level rise in the area.

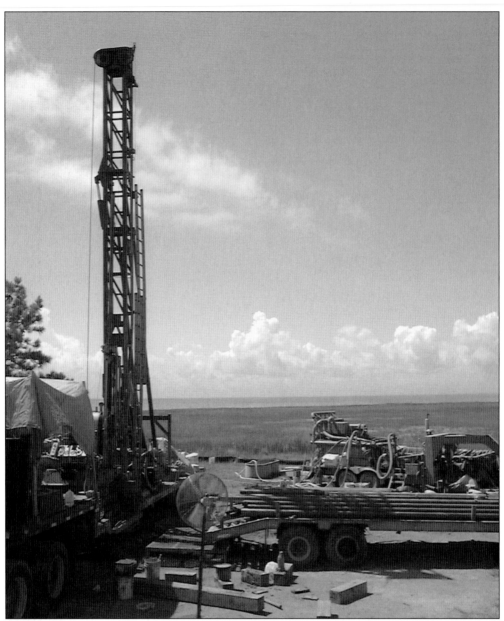

Mathews County lies above the northwest side of the world's sixth largest impact crater, formed 35 million years ago. Its center is beneath Cape Charles. This view looking southward across tidal wetlands near Bavon is of the rig used by the U.S. Geological Survey to drill a continuous corehole into the crater in 2001. The more than 2,300 feet of core penetrated overlying sediment, impact rock, and bedrock. By studying it, scientists learned about the effects of the structure on the regional groundwater system and drinking water quality. Their report is available online at http://pubs.usgs.gov/pp/2006/1731/PP1731.pdf. In 2002, the U.S. Geological Survey and Prince William Network produced an electronic field trip, *The Chesapeake Meteorite: Message from the Past*, to tell the story of the impact event. Sixth-grade students from Thomas Hunter Middle School participated in the program. (Photograph by E. Randolph McFarland; courtesy of the U.S. Geological Survey.)

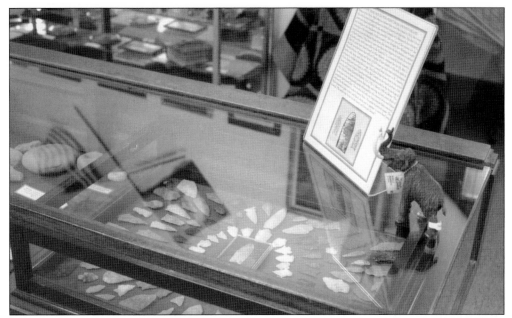

An arrowhead display at the Gwynn's Island Museum is shown beneath information about prehistoric animals hunted by early humans. Mastodon teeth and tusks are also on exhibit at the museum. Large mammals roamed North America for more than a million years. Their extinction coincided with the end of the last Ice Age and the appearance of the first humans on this continent. (Courtesy of the Gwynn's Island Museum.)

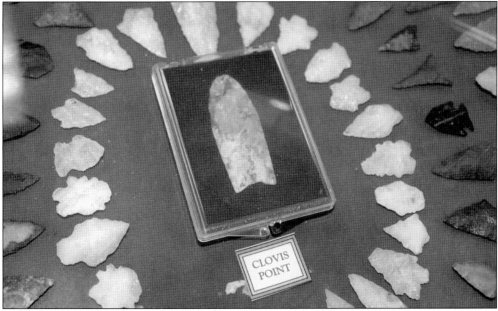

Clovis points, such as this one found on Gwynn's Island, are associated with the earliest humans in North America. First discovered in Clovis, New Mexico, they are related to theories of humans coming to North America from Asia by way of Alaska's Bering Straits. Recent theories describe early humans coming to North America's east coast from Southwest Europe via the ice-packed Atlantic. (Courtesy of the Gwynn's Island Museum.)

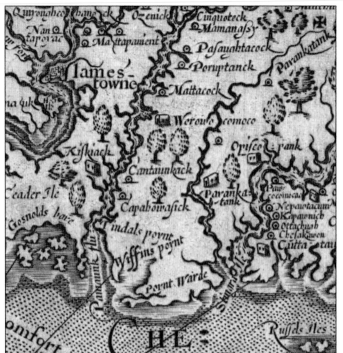

Jamestown, the site of English settlement in North America in 1607, is less than 50 miles from Mathews as the crow flies and approximately 100 miles distant by water. In June 1608, Capt. John Smith explored the Chesapeake and Stingray Isle, so named because he went ashore there after being wounded by a stingray barb. (Detail from *Virginia discovered and discribed by Captayn John Smith*, London, 1624; courtesy of the Library of Congress.)

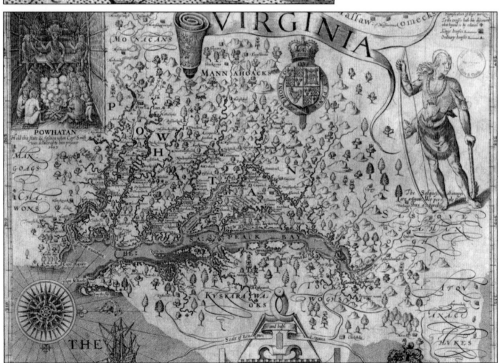

Early Virginia Company adventurer Hugh Gwin explored the island Smith called Stingray Isle in 1611. He settled there with his family, indentured servants, and slaves between the Virginia Indian massacres of 1622 and 1644. (*Virginia discovered and discribed by Captayn John Smith*, London, 1624; courtesy of the Library of Congress.)

Two

THE KINGSTON PARISH YEARS

Virginia was founded in 1607 as a trading outpost, which almost failed after John Smith's departure and the cold hardships of the winter of 1609–1610. Lord De La Warr arrived in 1610 and convinced the original settlers not to give up, and afterward ship after ship of new settlers arrived. Welshman Hugh Gwin was one such new arrival. He laid claim to an island at the mouth of the Piankatank that would became part of Mathews County.

Relations with the Virginia Indians were unsettled, and a 1622 massacre of settlers once again almost finished the colony. In 1624, the Virginia Company's corporate charter was revoked and the settlement became a royal colony. The king governed the colony through his council, and the stock company's legacy was the House of Burgesses. The official church was the Church of England. The colony was divided into parishes, which served as the local governing body through their vestries. Later counties became the principal units of local government.

An early-1700s priest said that about 2,000 souls lived in Kingston Parish. Accounts compiled for a 1949 special edition of the *Gloucester-Mathews Gazette-Journal* reported that Kingston Parish consisted of 46,537 acres divided among 115 landowners, 11 estates of 1,000 acres, and an average of 297 acres per person for the rest.

The boundaries of Colonial-period Kingston Parish include most of modern-day Mathews. It was well suited for development and industry in an age when rivers and creeks served as thoroughfares. The Kingston Parish vestry was responsible for 17th- and 18th-century issues concerning social welfare. The vestry's register of marriages and births from 1749 to 1827 remains a key tool for genealogists. There was a church court, but another court system overseen by wealthy landowners developed. In time, these county courts became more central to governance in the years leading up to the American Revolution.

Increasing numbers of Baptists and Methodists came to Mathews. Finally the American Revolution weakened the position of the Anglican church. After the Revolution, Kingston Parish Church no longer played a government role.

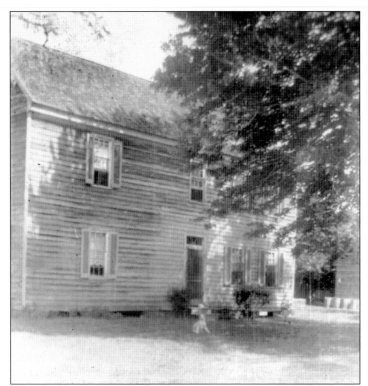

In 1635, Hugh Gwin's family settled on the island known by his name. Sea captains George Keeble and Thomas Reade and their families joined him. Their early houses were log buildings. Later the Keeble house, seen here, was built at Cherry Point on the island's northern tip. They built a shipyard on Reade's (today Edwards) Creek. (Courtesy of the Gwynn's Island Museum.)

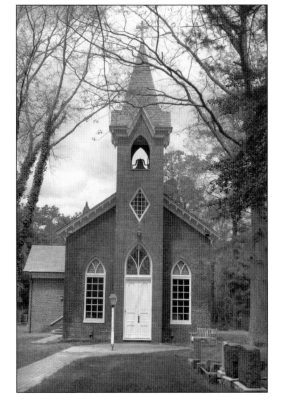

Kingston Parish was established in about 1652 as one of four Gloucester parishes to administer the affairs of church and society. The parish church is believed to have been located on the site of the current Christ Church, seen here. The glebe, or farmland, that supported the church was located across the creek on the peninsula formed by Put-in and Woodas Creeks and the East River. (Photograph by the author.)

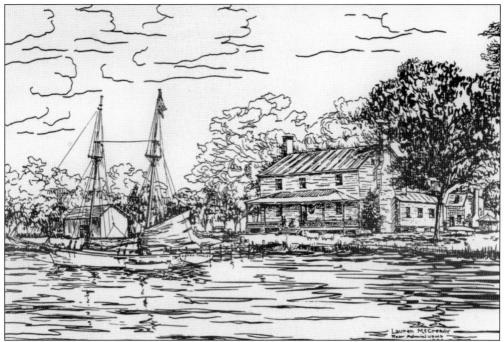

Isleham was the home of militia colonel and sheriff Sir John Peyton. His grandfather, Maj. Robert Peyton, was living in Kingston Parish as early as 1683. Other 1600s land records include the names Armestead (Armistead), Bohannon, Billups, Curtis, Davis, Degges (Diggs), Dudley, Elliot, Forrest, Lillie (Lilly), Ludlow, Marchant, Mechen (Mecham), Morgan, Putnam, and others. The above drawing of the house built on the property between 1832 and 1850 is by Lauren McCready. His father, Thomas, was born at Isleham in 1877. The artist includes a representation of the schooner *Clara Tinsley*, built by shipwright Capt. Gabriel Francis Miller, on Blackwater Creek. After the McCreadyes, Charles Edgar and Alice Miller lived at Isleham. The mid-20th-century photograph below includes the original kitchen, where a fireplace brick is etched with the date 1711. (Top, drawing by Rear Adm. Lauren S. McCready. Bottom, courtesy of Katherine Miller Hendrick.)

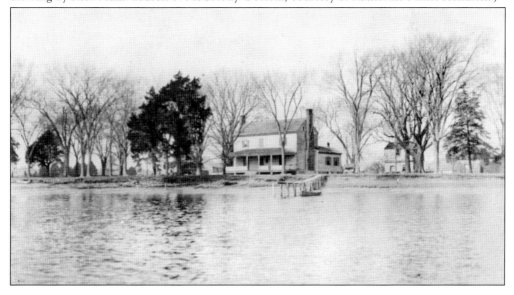

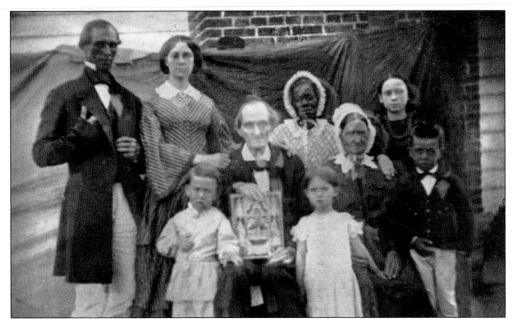

William Lilly Smith (seated), son of James Smith of Maryland and Elizabeth Lilly of Kingston Parish, probably met his wife, Joice Respess Billups, when stationed at Cricket Hill during the War of 1812. They united four Mathews families—Smith, Lilly, Respess, and Billups. Presumably the tintype photograph was taken when Smith presented a Bible to daughter Louisa and her husband, Thomas Williams. William Lilly Smith died in 1859. (Courtesy of Joice Smith Davis.)

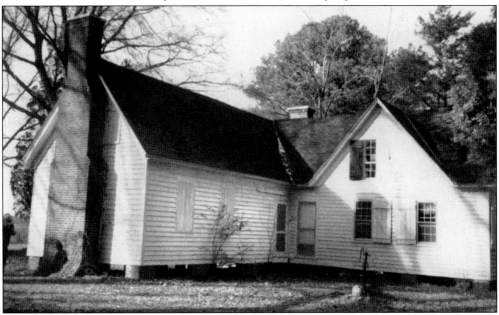

This Lilly's Neck home shows that angled additions were often made to houses as families grew. The Lilly family settled on a neck between today's Diggs and Moon areas. Their log house burned in the 1700s, and descendants built the first part of this house. Typical construction features include a brick pier foundation and wood shutters. A pump for well water stands in the yard. (Courtesy of Catherine C. Brooks.)

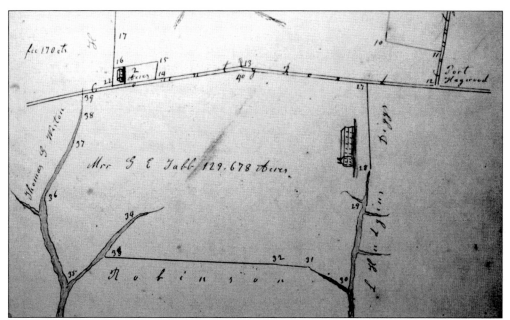

In 1711, William Smith was granted land "upon the North side of Horn Harbour Creek." Thomas Smith built Centerville in 1730. Descendant George Edward Tabb held the early-19th-century estate. He and his wife, Mary Harrison Randolph, enlarged Centerville and named it Woodstock. Descendants owned the central Mathews property until 1939. (Courtesy of the Mathews County Circuit Clerk's Office.)

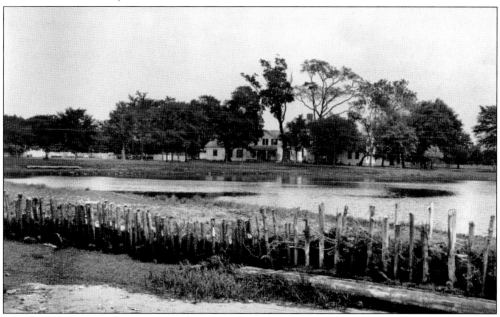

Samuel Williams and his son, Thomas, built a house on the East River before the end of the American Revolution. Later John Patterson planted Lombardy poplars and named it Poplar Grove. His wife was Elizabeth Tabb, and their daughter was Maria Booth Patterson. This view of the East River home was taken across the millpond in 1909. (Photograph by Herman Hollerith Jr.; courtesy of the Chesapeake Bay Maritime Museum.)

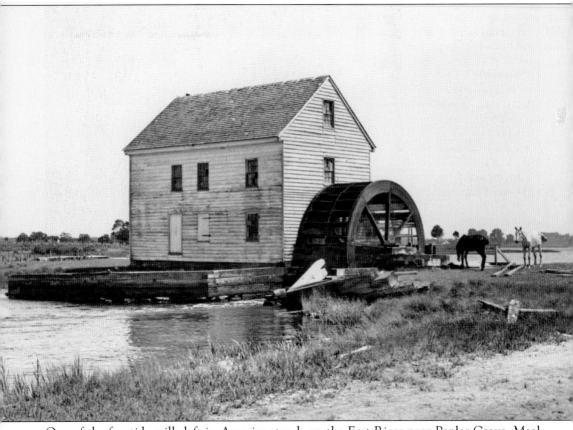

One of the few tide mills left in America stands on the East River near Poplar Grove. Meal was ground there for Revolutionary War troops. Maria Booth Patterson inherited Poplar Grove and lived there with her husband, Christopher Tompkins. They were the parents of Capt. Sally Tompkins, CSA, the only woman commissioned in the Confederate army. The mill burned during the Civil War and was rebuilt. (Photograph by Herman Hollerith Jr.; courtesy of the Chesapeake Bay Maritime Museum.)

This steep-roofed home in Winter Harbor was built in the 1700s. James Grayson Brooks, born in 1888, and his younger brother, George Enos Brooks, born in 1893, had records to show that their grandfather was born in the house. The house originally had a rail around the porch on which neighbors leaned when they gathered to talk in the evening. (Courtesy of Catherine C. Brooks.)

The original Brooks house kitchen burned in the early to mid-1800s. The Brookses built the large one, seen here, where slaves slept upstairs and cooked and washed in the downstairs room. After they were freed, the upstairs was made into a loom room where the women wove the wool from sheep they raised on the farm. They sewed and quilted downstairs. (Courtesy of Catherine C. Brooks.)

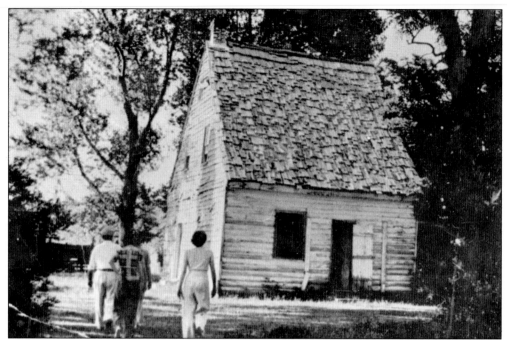

The Richard Respess home on Gwynn's Island was typical of the small and simple homes of early Mathews County watermen, farmers, and tradesmen. This structure was located on the site of the Gwynn's Island Condominiums near Callis Wharf. (Courtesy of the Gwynn's Island Museum.)

In the 1760s and 1770s, Edward Hughes, Richard Billups, Thomas Smith, and others ran advertisements in Williamsburg's *Virginia Gazette* with ships for sale. Edward Hughes, who lived "on the head of the East River," advertised a new 71-ton schooner made of "the best white oak plank and timber." Billups advertised an 80-ton sea schooner and a 50-ton sloop. Thomas Smith offered "a new ship, of 236 tons, well calculated for the Tobacco trade, well built of the best seasoned plank and timber." (Photograph by Herman Hollerith Jr.; courtesy of the Chesapeake Bay Maritime Museum.)

Three

FROM THE AMERICAN REVOLUTION TO THE CIVIL WAR

In April 1775, concerned by revolutionary sentiment, Virginia's royal governor, John Murray, Fourth Earl of Dunmore, ordered British marines to remove gunpowder from the Williamsburg magazine. Virginians reacted angrily. The unpopular governor gathered naval and Loyalist forces and fled to Norfolk where he remained through January 1776, when the city was burned. The fleet turned north, looking for a base of operations. Dunmore's flotilla anchored off Gwynn's Island and occupied it on June 1, but the Loyalists were defeated on July 9, 1776. A July 20, 1776, article in the *Virginia Gazette* described the battle and victory by the revolutionary forces. In the end, Dunmore's "fleet went off in a sad plight, and must be at a great loss where to go."

In summarizing the impact of Dunmore's occupation, historian Peter Wrike has written, "It took years to restore the island's agricultural productivity." Mathews continued to be affected by the Revolution until the last pitched battle was fought and the British surrendered in October 1781 at nearby Yorktown and Gloucester.

Mathews's earliest landholders had worn out the richest tobacco-producing soils, and the shipbuilding industry had used up all of the old-growth hardwood forest. Hugh Gwin's descendants had left the island he had founded more than 150 years earlier. The remaining shipbuilders and farmers sought relief in matters of governance, and a separate county was established in 1791.

The new courthouse and its attendant facilities were slated to be centrally located. Joseph Martin described it in 1835: "The Court House Village, called Westville, which was renamed Mathews Court House, is the seat of government. It is located on Putin Creek flowing in from East River." The village had "about 30 houses, 4 mercantile stores, 1 tanyard, 3 boot and shoe factories, 1 tailor, 2 blacksmiths, 1 saddler, 1 carriage maker and 1 tavern. The public buildings are very neat."

Although no battles were fought in Mathews County during the Civil War, farms, mills, and storehouses were scavenged for food on many occasions, especially to supply the batteries at Gloucester Point that were occupied by Federal forces.

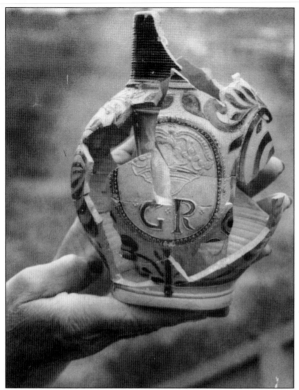

Peter Wrike, the author of *The Governors' Island: Gwynn's Island, Virginia During the Revolution*, wrote that Dunmore's fleet "was the largest hostile fleet to ever sail in the Chesapeake Bay." Fragments of a blue-on-gray stoneware jug made in the Rhineland and marked with "GR" for George Rex represent the type of artifacts that remain to enliven interpretation of this momentous event in Mathews's history. (Courtesy of the Gwynn's Island Museum.)

On June 1, 1776, the *Virginia Gazette* reported, "Gwin's island, which contains 2300 acres of land, with about 500 head of cattle, 1000 sheep, . . . is now possessed by the enemy. Lord Dunmore landed 800 men . . . who have thrown up an entrenchment on the land side. . . . The Gloucester militia were assembled on the opposite shore." (From the Thomas Jefferson Papers, Manuscript Division; courtesy of the Library of Congress.)

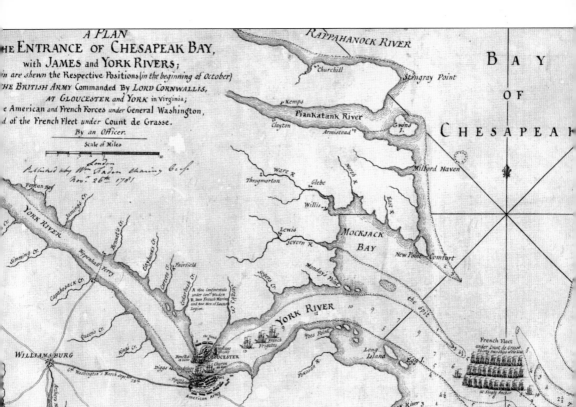

Shots were fired from Cricket Hill, and the American militia under Andrew Lewis took the island back from a British force largely reduced by smallpox. The *Virginia Gazette* announced, "General Orders, Camp near Gwyn's island, July 12, 1776. General Lewis cannot leave camp without expressing his approbation of the conduct of the officers and soldiers at this station. The fatigues they have gone through with cheerfulness, and the great services they have rendered their country, justly entitle them to his hearty thanks." It would take five more years for Americans to win independence. The last important battles of the war were fought at nearby Yorktown and Gloucester Point. The Cricket Hill Chapter of the Daughters of the American Revolution erected a granite memorial in front of the old clerk's office on the Mathews Courthouse Square in 1928 to commemorate the Battle of Cricket Hill. (Detail from a 1781 map; courtesy of the Library of Congress.)

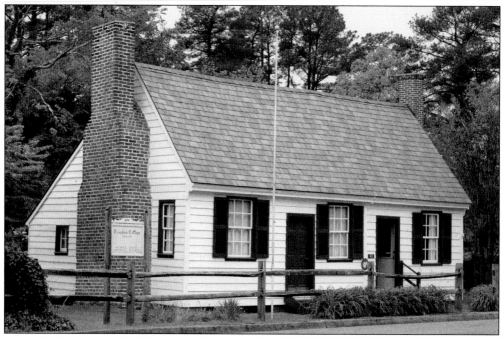

Around 1800, local builder Richard Billups constructed the courthouse and other early buildings on the square including the jail and clerk's office. Christopher Tompkins, a prominent merchant, planter, and shipbuilder, operated a mercantile store across from the square. The store was built around 1815. It is now the headquarters of the Mathews County Historical Society. (Photograph by the author.)

Records showed that Thomas James accumulated an impressive amount of land and a number of buildings in Mathews Court House between 1815 and 1845. His store may have been located on Mathews's main road. He supplied the daily needs of citizens for dry goods, hardware, fabric, and other imported goods that could not be supplied by the farmer or other area trades people. (Photograph by the author.)

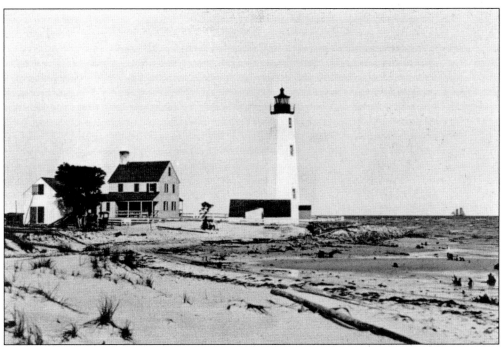

The Industrial Revolution sparked a rapid shift toward mechanization as well as an increase in goods and trade. As commerce and ship traffic increased on the Chesapeake Bay, lighthouses were built to warn ships away from shallow areas. The first marked the entrance to the Chesapeake Bay at Cape Henry. The second, Old Point Comfort, was completed in 1802 to guide traffic into the port of Hampton Roads. A third, Smith Point, marked the entrance to the Potomac. The fourth lighthouse was built at New Point Comfort, Mathews's most southern tip. The light guided ships traveling the Norfolk-to-Baltimore route around the shoals at the point where the Chesapeake Bay's western shore is closest to Virginia's Eastern Shore. (Top, photograph by Herman Hollerith Jr.; courtesy of the Mathews County Historical Society. Bottom, photograph from a postcard; courtesy of Catherine C. Brooks.)

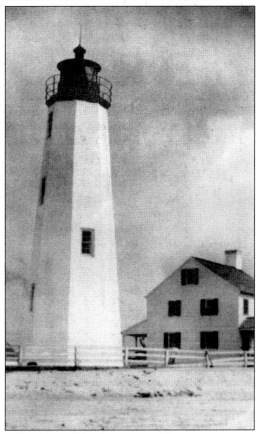

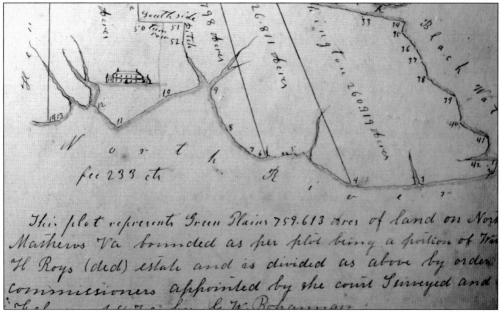

James H. Roy built Green Plains on the North River between 1798 and 1802. He married Elizabeth Booth, daughter of George Booth of Belleville, located across the river on one of Gloucester's earliest patents. John Booth, her ancestor, and John Boswell, Booth's business partner, acquired the land in the mid-17th century and operated a tobacco export business between Gloucester and London. (Courtesy of the Mathews County Circuit Clerk's Office.)

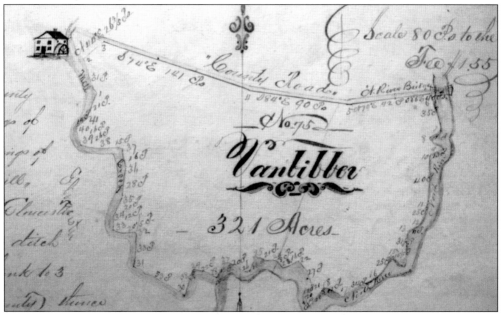

North End was originally owned by John Page. Isaac Foster completed this survey in 1822 for later owner Henry VanBibber. Dr. Henry Wythe Tabb married VanBibber's daughter Hester Eliza Henrietta VanBibber, who died in 1823. Dr. Tabb continued to live at North End until his house, Auburn, was completed in 1824. The survey was decorated with a sketch of the property owner's water mill. (Courtesy of the Mathews County Circuit Clerk's Office.)

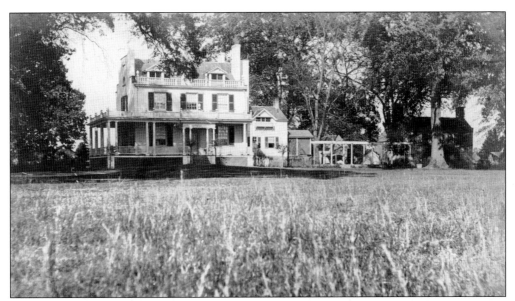

Auburn was built by Philip Tabb for his son, Dr. Henry Wythe Tabb. Dr. Tabb was married three times. Many Tabb children and grandchildren were born in the elegant Georgian home. The c. 1900 owner, Charles Heath, encouraged the local daffodil industry by propagating bulbs for Dutch companies. (Courtesy of William B. and Martha Ellen Brockner.)

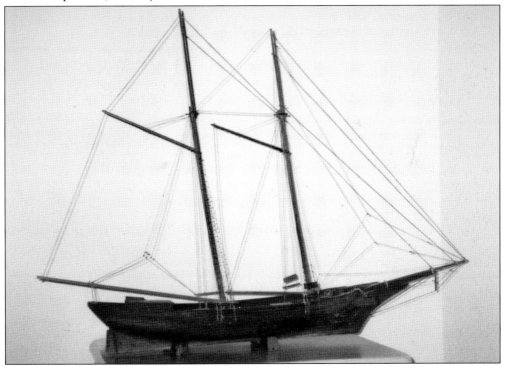

The frenzy of shipbuilding in Mathews had peaked in the early 1800s, but shipbuilders such as Gabriel Miller (1766–1845) still built fine craft. One was the two-masted schooner *Eugenia*, represented here in a photograph of the builder's scale model. The schooner was built at his shipyard on Blackwater Creek in 1843. (Courtesy of Katherine Miller Hendricks.)

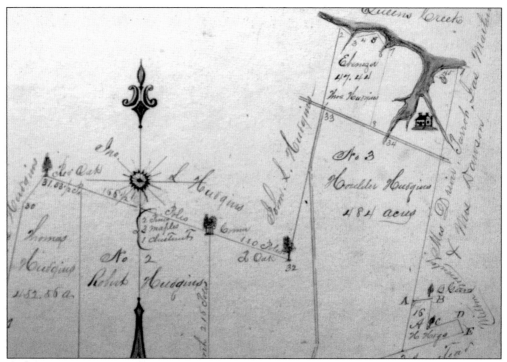

Although there were no Civil War battles fought in Mathews, the county was often raided by Union forces who stole food for their troops. Mary Hundley Hudgins Edwards recorded in her diary that a Union steamer was anchored near William Forrest's home and that Houlder Hudgins's property was raided. Soldiers took turkeys and moved on to the next property. (Courtesy of the Mathews County Circuit Clerk's Office.)

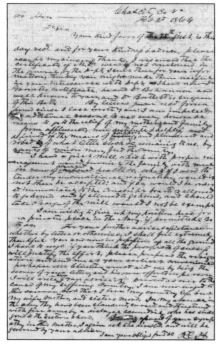

Lt. Robert E. Hudgins of the 24th Regimnt of Virginia Cavalry, Company, D, wrote to his commanding officer asking for leave "to go to the relief of my mother and family, from affluence, not destitute and helpless, deprived of the mans of support, and plundered and robbed of what little stock and c. remaining to us by agents of union men, fled the country." (Courtesy of Woody, Nancy, and Ron James.)

Sally Tompkins was born in 1833 at Poplar Grove in Mathews County and was the only woman to be granted a commission in the Army of the Confederacy. "Captain Sally" founded and directed Robertson Hospital in Richmond, where over 1,300 Confederate soldiers were cared for between 1861 and 1865. She is buried at Christ Church Cemetery on Williams Wharf Road. (Photograph by the author.)

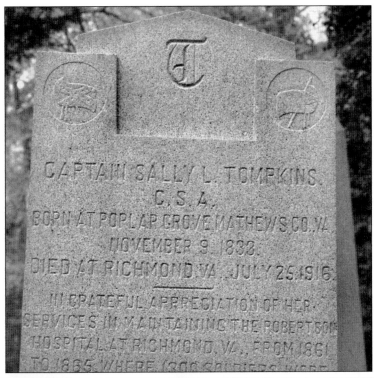

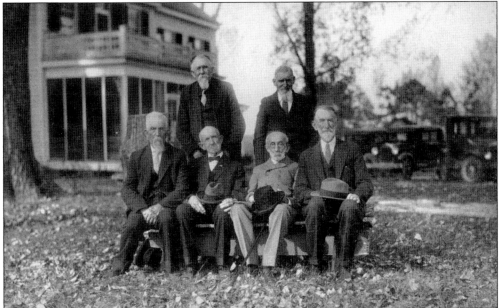

Paul Titlow photographed Mathews's remaining Confederate veterans on March 19, 1931, at Palace Green, home of Maj. Giles B. Cooke. Cooke was the last surviving member of Gen. Robert E. Lee's staff, the oldest Episcopal minister, and the oldest graduate of Virginia Military Institute, where one of his professors was Gen. "Stonewall" Jackson. Included in the photograph are, from left to right, (seated) John Lewis, Walter R. Stokes, Cooke, and J. Wesley Minter; (standing) Elkanah Diggs and W. S. Burroughs. (Courtesy of Tidewater Newspapers, Inc.)

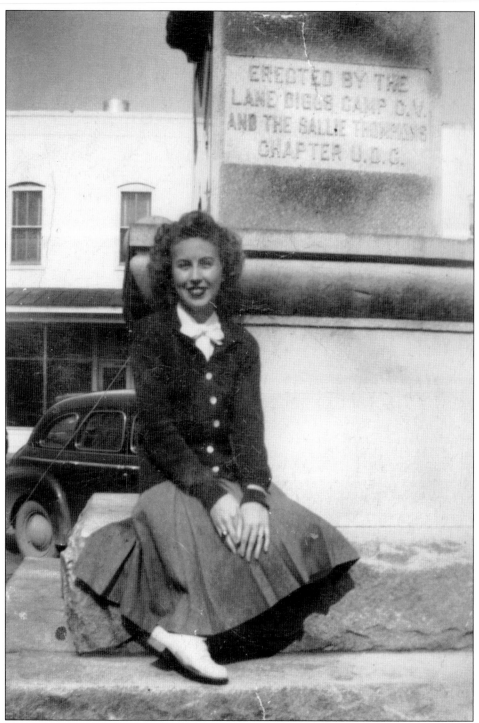

The Lane-Diggs Camp of the Confederate Veterans and the Captain Sally Tompkins Chapter of the United Daughters of the Confederacy erected a Confederate monument in front of the old courthouse building. Louise Anderton Bailey posed at the foot of the monument for this photograph about 1940. (Courtesy of Ralph Anderton.)

Four

HAPPY HOMES AND FERTILE FARMS

The Mathews motto, "Happy Homes and Fertile Farms on Smiling Waters," provides a convenient means to divide this chapter from the next. This one will focus on Mathews by land, and the next will present Mathews by sea.

With the end of the institution of slavery, a way of life that depended on unpaid labor came to an end. Though some of Mathews's large landowners had the means to move on to other places and sources of income, the transition for others was slow and difficult. Some former slaves continued to work for their old masters for food and a place to live.

In Mathews County, farmers raised tomatoes, potatoes, beans, and other such crops for markets served by schooners, then steamboats, then packets and trucks. Although other occupations existed—waterman, merchant, doctor—everyone farmed to some extent until electricity, cars, and, at last, grocery stores appeared. Most grew vegetables and fruits and raised chickens and other livestock to feed their families.

Catherine C. Brooks's books, *Walk with Me* and *Didn't Know We Were Poor*, are wonderfully entertaining resources that illustrate how networks of rural Mathews families worked and lived in a manner more connected to the earth. More photographs that illustrate the organization and growth of families around schools, stores, and organizations will be presented in chapter six.

Crops as varied as lumber, daffodils, berries, pumpkins, landscape plants, and asparagus have continued to meet the needs of Mathews's farmers to supply a market.

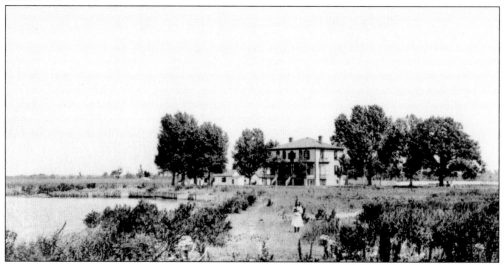

Herman Hollerith Sr. and family came to Mathews by steamboat in 1896. The inventor of the electric tabulating machine system first used to simplify the 1890 Census, Hollerith purchased John Campbell's farm in 1909. In 1917, a new house replaced the original, pictured here. The land is nearly treeless because they were felled earlier for shipbuilding, fuel, and timber, which opened land for farming. (Photograph by Herman Hollerith Jr.; courtesy of the Mathews County Historical Society.)

This print illustrated "Some Landmarks of Old Virginia," by Allen C. Redwood a *Harper's New Monthly Magazine* article, in 1878. The author wrote, "At the mouth of the little river Piankitank . . . is a long low strip of land, called Gwinns Island. It is separated from the main-land by a narrow thoroughfare, and forms a natural breakwater. . . . Under the incessant battering of easterly storms the island is gradually washing away. A Tory family . . . returned, after peace was proclaimed, to find the larger part of their estate already engulfed." (Courtesy of the Gwynn's Island Museum.)

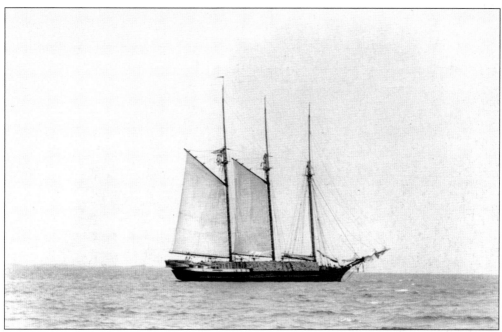

A photograph of a three-masted schooner, the *Edwin R. Kirk*, was taken in the early 20th century. It is loaded with lumber, possibly from a rural area such as Mathews. Timber was a key Virginia resource harvested to fill the needs of a growing nation. (Photograph by Herman Hollerith Jr.; courtesy of the Chesapeake Bay Maritime Museum.)

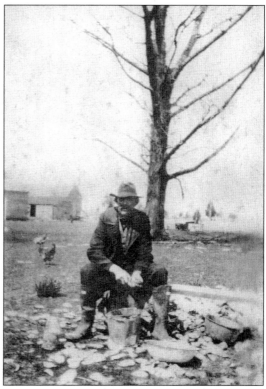

Prior to legislation giving ownership to Virginia, the broad oyster shore around the Smith property was considered a harvestable area that belonged to the landowner just like the interior land where field crops grew. William Luther Smith, who died in 1928, is seen here shucking oysters for a family meal or to sell. The pile of shells grew in the same location, and as a child in the 1940s, Smith's granddaughter Joice Smith Davis remembers it being head high. (Courtesy of Joice Smith Davis.)

When this photograph was taken, Grayson Brooks owned this barn on Bethel Beach Road. It was probably built in the late 1800s or early 1900s and reflects a common rural architectural form. Many similar structures dotted the Mathews landscape 100 years ago. (Courtesy of Catherine C. Brooks.)

Walter Gabriel Jones (1837–1919) and his wife, Sarah Elizabeth, had nine children and built a large home on Blackwater Creek where their daughter Carrie lived until her death in 1970. Generations of the Jones family have farmed and run the store and post office at North. Walter and Sarah are representative of the large and self-sufficient farm families who lived quietly in the post–Civil War rural South. (Courtesy of Mary Belle Jones Lewis.)

John Wesley Ashberry, who died in 1941, owned a small farm on Tick Neck Road at the head of the East River. (Courtesy of Catherine C. Brooks.)

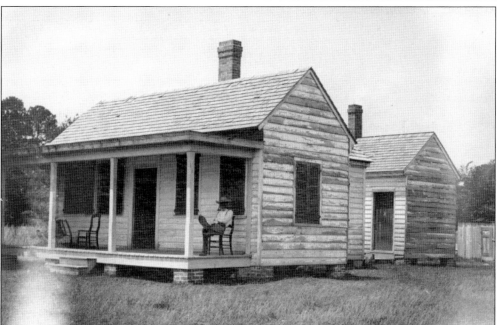

This photograph of the miller's house at Poplar Grove captures a scene typical of the post–Civil War South, where estates were often peopled by former slaves and their descendants who continued to live and work on the property. Correspondence, diaries, and other 1800s documents from Poplar Grove are available for further research at the Virginia Historical Society. (Photograph by Herman Hollerith Jr.; courtesy of the Chesapeake Bay Maritime Museum.)

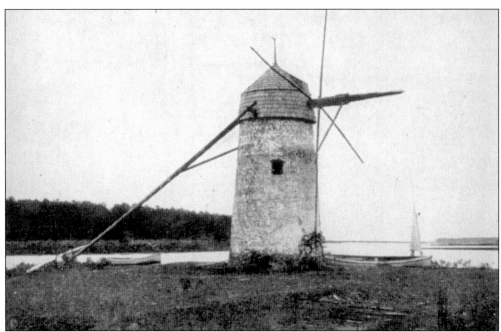

In a day before flour and meal were readily available at the general merchandise or grocery store, it was necessary for farmers to grow corn and wheat for milling. Windmills were typical of coastal areas, and tidemills, like the one at Poplar Grove, also satisfied the need for power to turn working parts in mostly flat areas like Mathews. A water-powered mill operated at North End farm (see page 26), where water flowed quickly enough downstream. Mathews's old windmills have been captured in numerous early photographs and in drawings that illustrate records in the circuit clerk's office. (Top, courtesy of Woody, Nancy, and Ron James. Bottom, courtesy of the Mathews County Circuit Clerk's Office.)

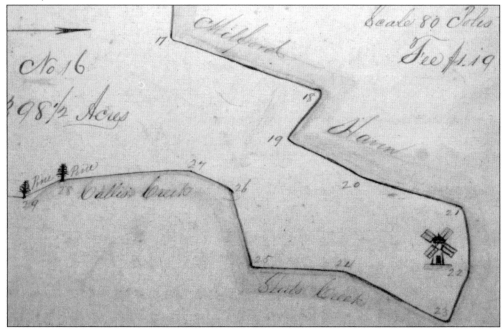

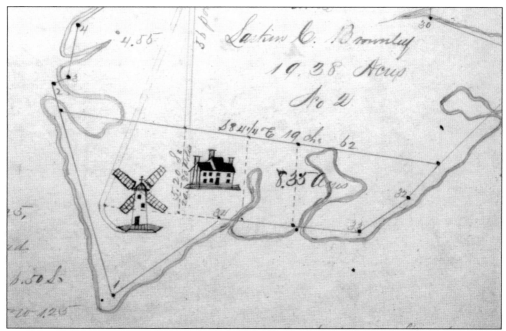

Mathews had as many as 10 windmills, which were attractive directional markers for travelers. The author or editor of the 1878 article in *Harper's New Monthly Magazine* selected a scene (page 28) that included a windmill to illustrate the article "Some Landmarks of the Old South." A millstone is still located on the Edwards property at Mill Point on Gwynn's Island. (Top, courtesy of Mathews County Circuit Clerk's Office. Bottom, courtesy of Woody, Nancy, and Ron James.)

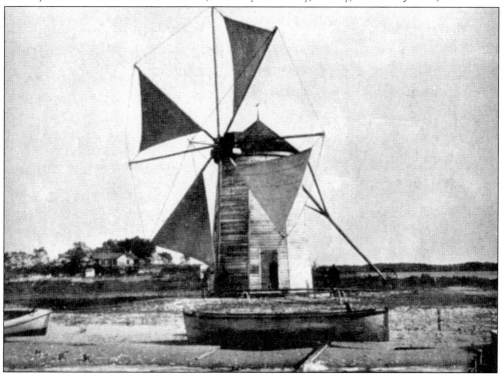

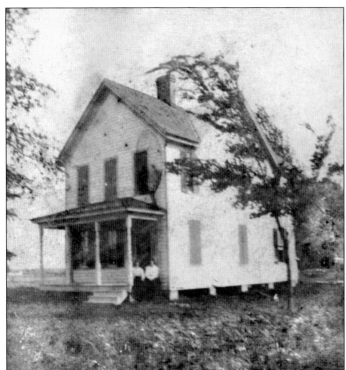

Onia A. White's house was built in Bohannon about 1896. While neighbors grew tomatoes, potatoes, and corn for shipment to ports from Baltimore to Norfolk, White raised only vegetables and some animals to meet the needs of his family. He ran a store about one and a half miles away and lived there during the week. Like most, he bought sugar, coffee, and other imported items. (Courtesy of Ralph Anderton.)

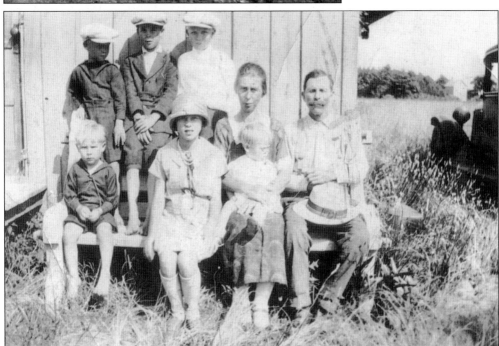

John Spencer Hall Jr. was born in September 1876. He moved from Port Haywood to Gwynn's Island and married Blanche V. Bensten on March 14, 1914. They farmed 19 acres around Cherry Point. About 1927, the couple was photographed with their children Willard, Hayward, Johnny, Hudson, Daisy, and baby Martha. (Courtesy of the Gwynn's Island Museum.)

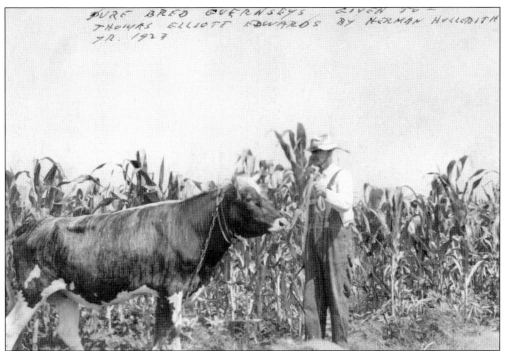

Herman Hollerith Sr. gave a purebred Guernsey to Thomas Elliott Edwards, seen here with the bull, in 1927. In *Memories from Mill Point*, Henry Gwynn Edwards discusses the use of the prize bull and includes a letter from Herman Hollerith Sr. concerning the sale of the bull. (Courtesy of the Gwynn's Island Museum.)

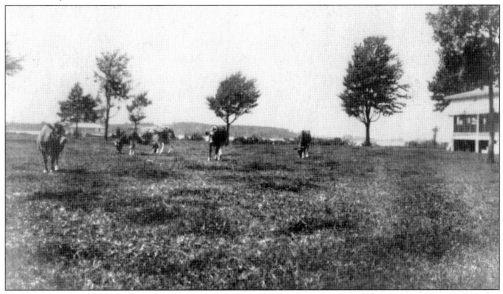

Hollerith Sr. said, "My entire life has been devoted to matters very far removed from farming . . . but I have never been so intensely interested in anything as I have in Guernseys." In 1921, Hollerith retired, and from then until his death in 1929, his time was "fully occupied with boats, bulls, and butter." (Photograph by Herman Hollerith Jr.; courtesy of the Mathews County Historical Society.)

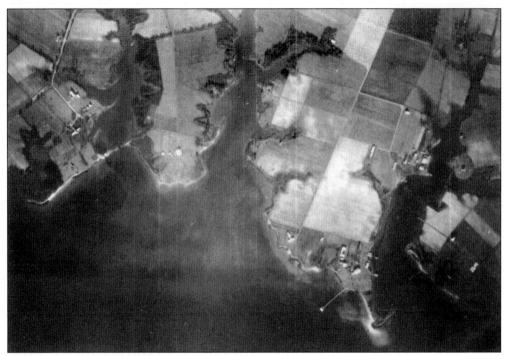

This aerial view of Mobjack Farm was taken when a military plane flew over the property in 1918. Mathews's farmers, including Hollerith, keep most of the county under cultivation. (Courtesy of the Mathews County Historical Society.)

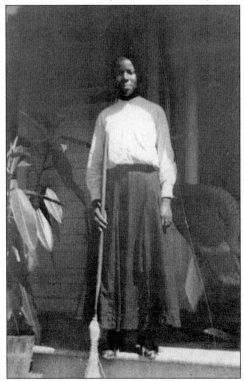

A servant with a straw broom posed for Herman Hollerith Jr. on the steps of Poplar Grove, where Hollerith's family vacationed until 1909. The photographer, son of Herman Hollerith Sr., the inventor, was born in 1892. Family legend holds that he developed his photographs in a closet at Brighton, the family's house on Mobjack Farm. (Photograph by Herman Hollerith Jr.; courtesy of the Mathews County Historical Society.)

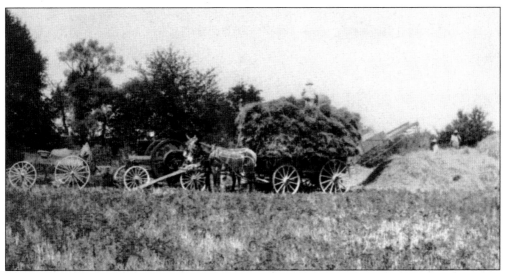

A threshing machine was used at Brighton in 1914. In collaboration with men and mules, it harvested and separated grain from stalks and husks. The hand-fed and horse-powered machine reduced the need for laborers and sparked riots among unemployed workers in other parts of the world. (Photograph by Herman Hollerith Jr.; courtesy of the Mathews County Historical Society.)

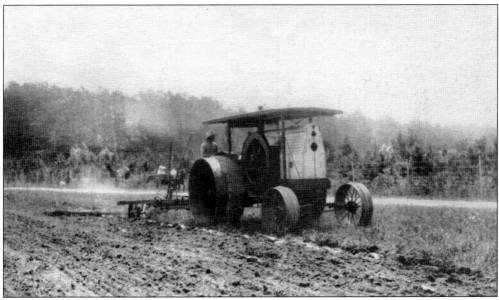

In 1915, Hollerith used an International Harvester tractor at Mobjack Farm while most of his neighbors used horses and mules. Farming with livestock was the norm for many more years. Early in the 20th century, International Harvester moved away from animal-powered equipment and toward motor vehicles. (Photograph by Herman Hollerith Jr.; courtesy of the Mathews County Historical Society.)

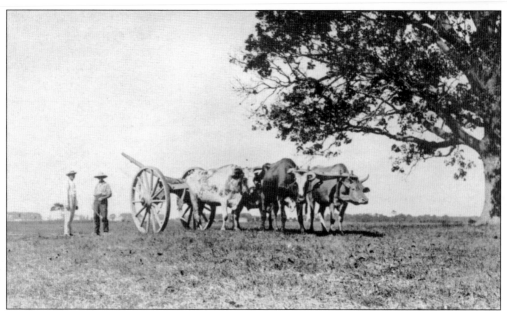

A team of oxen with a "carry log" worked the fields at Mobjack Farm. Carry logs were carts with two large wheels that were usually higher than the oxen's backs. (Photograph by Herman Hollerith Jr.; courtesy of the Mathews County Historical Society.)

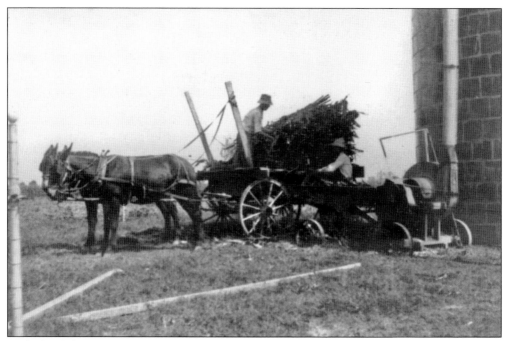

Mules hauled corn stalks and workers feed them into a silage cutter, where they are chopped and blown into the silo at Mobjack Farm for storage. (Photograph by Herman Hollerith Jr.; courtesy of the Mathews County Historical Society.)

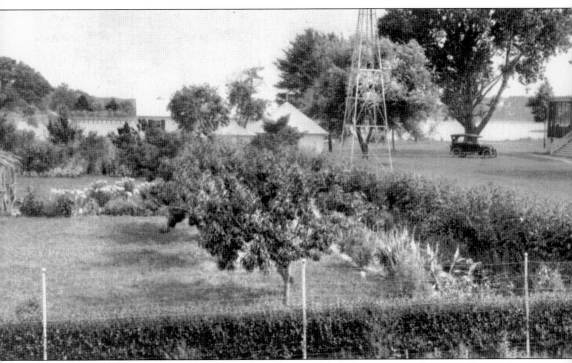

A vegetable garden and fruit trees behind Brighton yielded plenty to suit the everyday needs of the family. During the August hurricane of 1933, a niece of the Hollerith sisters, C. C. Hollerith, remembers the water rising to the top steps of the back porch. She sat on the steps, pictured on the right, and watched as melons and other garden produce floated by. (Photograph by Herman Hollerith Jr.; courtesy of the Mathews County Historical Society.)

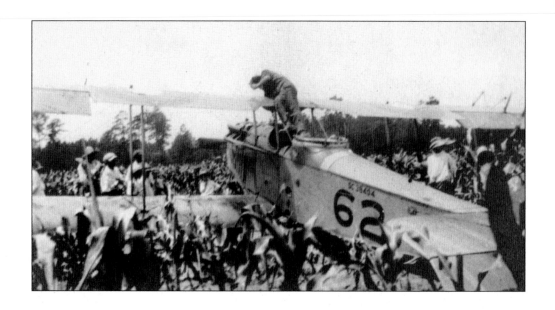

During World War I, training flights were conducted by the Army Air Corps from nearby Langley Field. One of several planes, including a two-engine bomber, made forced landings at Mobjack Farm in the Holleriths' cornfield. The pilots spent the night, and on the next day, another plane landed with equipment for repairs. A crowd gathered to see the planes leave. In the first photograph, corn stalks can be seen planted farther apart than we are used to seeing them planted today. In that period before the commercial fertilizers, seaweed and lime from oysters provided nutrients. (Both, photograph by Herman Hollerith Jr.; courtesy of the Mathews County Historical Society.)

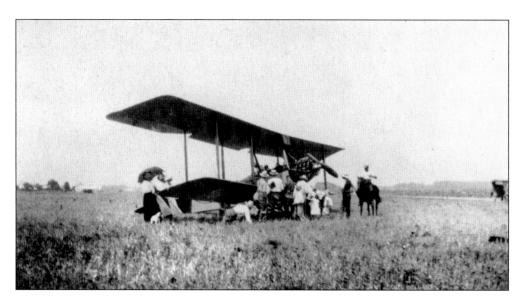

Roland Jones of North used his mules and horse, Molly, Dolly, and Jack, to cultivate his fields well into the 20th century. (Courtesy of Mary Belle Jones Lewis.)

Luther Smith (1856–1928), right, carries a pail of milk. Even when there were visitors, rural families needed to tend to animals and farm-related chores or gather food supplies for a meal. Smith's granddaughter, Virginia Smith, holds her grandfather Murden's hand. David Walter Murden was visiting from Portsmouth. (Courtesy of Joice Smith Davis.)

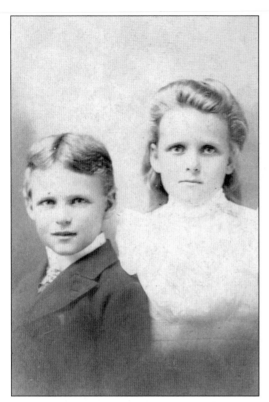

Alonzo and Laura Belle were children of Capt. Henry Howitt Foster and Catherine Belle Hodge. Foster was captain of the bugeye *Alexander Bond*, which another son, Benjamin Woodland, continued to operate. On July 15, 1926, the *Mathews Journal* reported, "Capt. B. W. Foster of Mobjack . . . has just arrived from Baltimore, where he took a cargo of potatoes, bringing back wheat for Dr. Tabb at Cow Creek Mill." (Courtesy of Richard Zietz.)

Katherine Franklin Diggs, daughter of William L. Diggs of Hopedale, her family home in the Diggs community, married William Luther Smith of Old Field Point on Billups Creek. She posed for a tintype with son Luther Seabrook Smith (1894–1964). Smith descended from the Billups and Lilly families. George Billups was given a patent in 1653 to land on the west of Billups Creek, and the Lilly grant to land east of the Creek dates to 1642. (Courtesy of Joice Smith Davis.)

William Edward Sadler of Dixie posed with his wife, Victoria Ann Booker, and their youngest children, Edward Henry and Sarah Ann Elizabeth, born in 1905 and 1907. Sadler owned Waterloo Farm and grew wheat, corn, potatoes, tomatoes, and other field crops. Edward, left, was one of the Sadler brothers who ran a large chicken operation there through the 1950s. Nearby their Edwards relatives grew daffodils. (Courtesy of Woody, Nancy, and Ron James.)

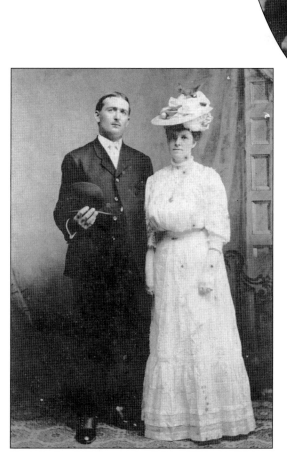

Enos Brooks of Hallieford married Clara Sadler of Hudgins in 1907. This photograph is thought to be their wedding picture. Brooks was a lighthouse keeper on Stingray Point lighthouse in the 1930s, and he owned a store in Hallieford. (Courtesy of Diana Hudgins Swenson.)

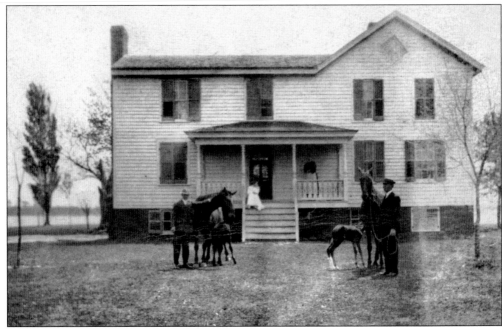

When this 1915 photograph of W. F. (left) and Maurice Davis and their horses was taken, the Davis family owned Myrtle Grove Farm, which was located on the East River just north of Mobjack. An Armistead family had lived there, but the house was plundered and burned in the Civil War. Later a Gwynn bought the property and built the center portion of the house in 1875. In 1890, he sold it to W. F. Davis, who farmed and conducted a variety of businesses. These included a tomato cannery and the sales and shipment of fertilizer, coal, cement, bricks from a Chickahominy River brickyard, and shingles. Others in the area would use his wharf as a shipping point. Potatoes, seen below in the field with W. F. Davis in the distance, were a key crop for trade. (Both, courtesy of Wilson Davis.)

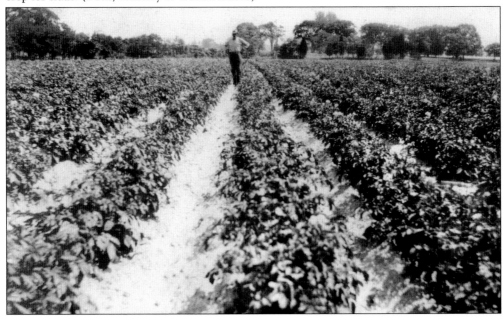

In the 1920s and 1930s, J. Newton Foster and Son operated a tomato and roe cannery at Grimstead on Gwynn's Island. Canned goods from Mathews's fields and waters were shipped from Callis Wharf to Baltimore and beyond. The baby on the label is Dorothy Foster Hearn. (Courtesy of the Gwynn's Island Museum.)

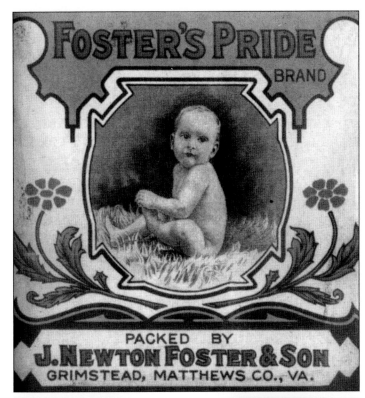

On the approximately 60-acre Edwards farm in Dixie, daffodils and field crops were grown for shipment to Northern markets through the first half of the 20th century. Two Edwards sisters and a brother lived there until the last died around 1990. The volunteer fire department destroyed the house during a training exercise, and the farm has become a subdivision. (Courtesy Woody, Nancy, and Ron James.)

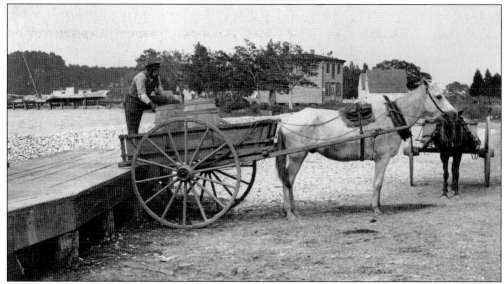

A laborer unloads barrels at Williams Wharf in the early 1900s. The former ship's chandlery or store can be seen in the middle distance, and a shipbuilding railway is off to the left. The East River wharf was an official port of entry for U.S. and foreign ships from 1805 to 1844 and the county's center of maritime activity. (Photograph by Herman Hollerith Jr.; courtesy of the Chesapeake Bay Maritime Museum.)

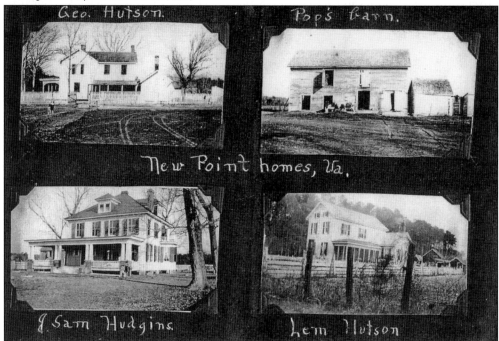

Clifton M. Hudgins of Alexandria, Virginia, kept a scrapbook with the title *Jolly Good Times in Mathews 1911–1951*, now at the Gwynn's Island Museum. He particularly enjoyed photographing homes, and the page seen here is of four structures in the New Point area in 1913. The wharfs at New Point and nearby Bayside were two of the most prosperous because of their prime Chesapeake Bay location. (Courtesy of the Gwynn's Island Museum.)

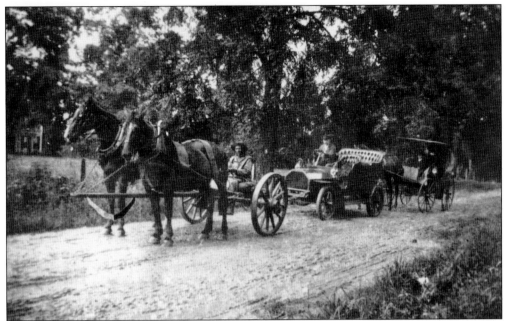

One of the earliest cars to appear in Mathews was this Waltham Orient. Some despised loud and smoke-sputtering cars. They often scared horses and interrupted quiet rides. Perhaps the driver of the horse-drawn cart got some satisfaction from the auto driver's unfortunate situation. (Photograph by Herman Hollerith Jr.; courtesy of the Mathews County Historical Society.)

North Carolina cousins visited the Jones family in North in the 1930s. Laura Belle Foster Jones (standing) entertains on her airy wraparound porch, which was a desirable room in a day before air-conditioning. Cars had become more common by this time, but the purchase of a new car was often news that warranted a mention in the *Mathews Journal.* (Courtesy of Mary Belle Jones Lewis.)

A woman's work was never done. In *Walk with Me*, Catherine C. Brooks said, "In the late 1930s and 1940s, Momma taught me to wash on Monday, iron on Tuesday, catch up and have some time for myself on Wednesday, sew or do special cooking on Thursdays, clean the entire ten-room house on Friday, and cook on Saturdays. Sunday was Sunday School and church service, followed by a scrumptious meal that had for the most part been prepared on Saturday." Alice Davis is seen here preparing a meal in the 1950s at Myrtle Grove. (Courtesy of Wilson Davis.)

Warren Frank Davis (1932–2006) worked a full-time job so that he could indulge in his passion, farming, as seen in this photograph taken in the fall of 1984. His generation experienced the post–world wars shift from the predominance of independent occupations on the land and water to civil service jobs and other occupations that involved the upkeep of a more mechanically dependent society. (Courtesy of Joice Smith Davis.)

Five

LIFE ON SMILING WATERS

The bays, rivers, and creeks that smile on Mathews have been stroked by paddles, fanned by sails, and churned by paddle wheels. The waterways enchant all who surrender to their charms.

More than 2,000 seagoing vessels were launched along Mathews's edge during the 1700s and 1800s. According to Peter Wrike, there were six shipyards in the East River. Others were in Blackwater Creek, Cobbs Creek, Garden Creek, Winter Harbor, Milford Haven, North River, Pepper Creek, Point Breeze, Put-in Creek, Sloop Creek, and Stutts Creek. Families with surnames such as Ashberry, Billups, Gayle, Hudgins, Hunley, Miller, Smith, and others were engaged in the trade. Boats, models, and documents have taken on a life of their own for maritime historians and descendants of shipbuilders and sea captains.

Schooners, bugeyes, log canoes, and skipjacks were used to fish, oyster, and crab. Hollerith photographs document the final years of working sailboats. While travel became more common, seafood harvests declined and land transportation increased, making large working vessels and numbers of watermen unnecessary. Today a few deadrise boat builders hold on to the occupation. The Mathews Maritime Foundation and the Mathews County Land Conservancy have been formed to document the maritime community and exhibit materials that interpret past times.

For generations, Mathews people have lived with water all around, crossing on ferries and using boats to get where they needed to go. Swimming and playing on the waterfront were favorite pastimes. When they sought 20th-century occupations and especially when the world wars broke out, it was only natural that many men went to sea on passenger liners or freighters or joined the navy and Merchant Marine.

The waters around Mathews have not always smiled. The strength of water moved by wind and weather reminds us of powers not within man's control.

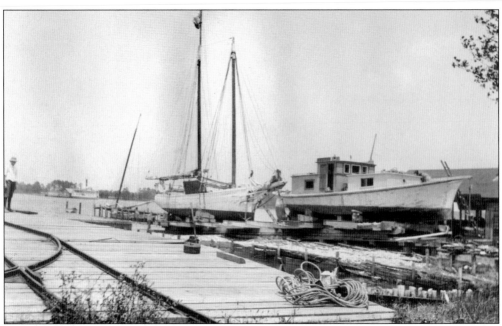

A round-stern bugeye is pictured alongside a deadrise in the ship's railway at Williams Wharf. Across the East River in the distance, a steamboat is docked at Hicks Wharf. The early-1900s scene reflects the evolution of shipbuilding and river-born commerce in Mathews. The early shipbuilding industry grew to meet the demand for ocean-going ships. An East River neighbor, Thomas Smith, advertised his newly built 236-ton ship to those engaged in the tobacco trade in the *Virginia Gazette* on March 26, 1767. After the American Revolution, ships were built for the navy and privateers. In 1835, there were 200 ship carpenters in Mathews. The Civil War sparked changes in technology that were reflected in the mix of ships on the East River, but boats like the one at the bottom, probably Charles Sadler's bugeye, were used into the early 1900s. (Top, photograph by Herman Hollerith Jr.; courtesy of the Chesapeake Bay Maritime Museum. Bottom, courtesy of Diana Hudgins Swenson.)

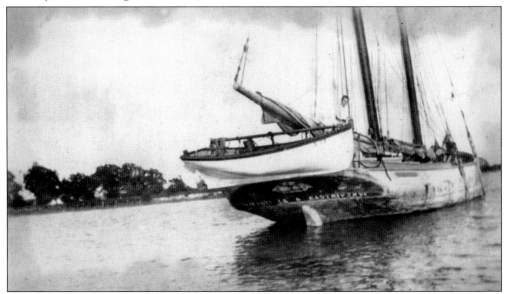

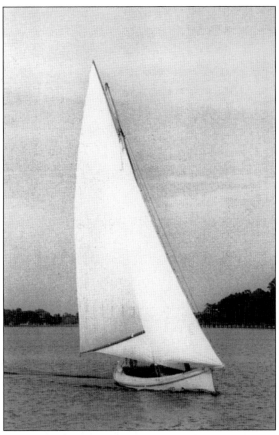

Early boats designed to fish, oyster, and crab in the Chesapeake Bay were log canoes. The Miles family log canoe is seen here being pushed by a good wind. The small workboat under sail became a favorite for racing. This Mathews-owned boat was built in Poquoson, Virginia, where the builders of the craft were said to be the best. Log canoes were converted to motor power as the means became more common after 1900. Seen below, motorized log canoes brought their catch to Bayside Wharf. Buckets on pulleys lift fish from the boats. (Top, courtesy of Wilson Davis. Bottom, photograph by Herman Hollerith Jr.; courtesy of the Chesapeake Bay Maritime Museum.)

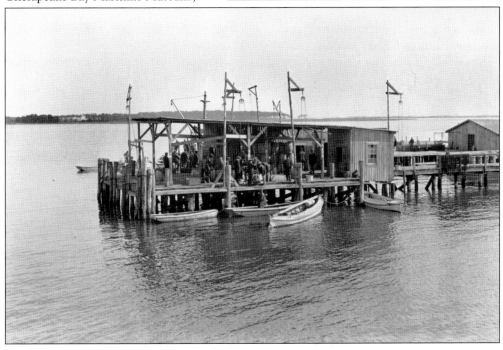

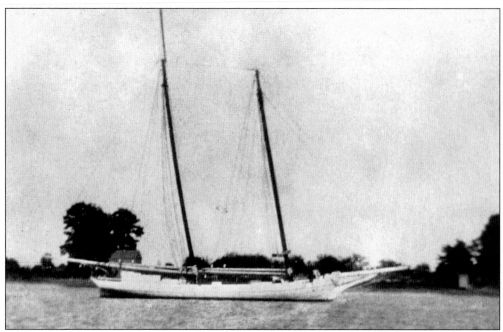

The bugeye was designed in the mid-1800s for dredging oysters in the shallow waters of the Chesapeake Bay. It was a shallow draft boat like the log canoe but was larger and more powerful like the earlier two-masted schooners. The *Banshe*, above, was owned by Capt. Johnny Miles. He used the wide boat for hauling oysters and lumber to Baltimore and returning with goods like commercial fertilizer. After the bounty of oysters was dredged, the smaller skipjack was used for oystering. The skipjack *Georgie Lee*, below, was photographed around 1920. (Top, courtesy of Wilson Davis. Bottom, photograph by Herman Hollerith Jr.; courtesy of the Chesapeake Bay Maritime Museum.)

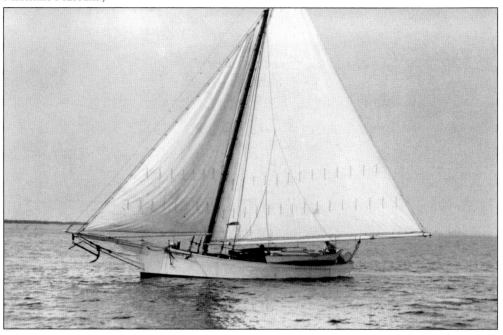

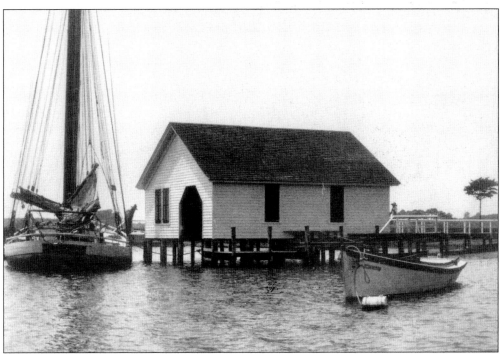

Around 1920, Capt. Ben W. Foster took potatoes from Mobjack Farm on the *Alexander Bond* and returned with coal to heat the Hollerith family home, Brighton. The broad and flat bugeye is seen to the left of their boathouse. In 1929, Foster received a hefty fine for violating Oyster Law, enacted to regulate harvesting and trade of the declining mollusk stock. (Top, photograph by Herman Hollerith Jr.; courtesy of Wilson Davis. Bottom, courtesy of Ralph Anderton.)

No. 5319 Receipt for Fines
For Violation of Oyster Law

$ 20 00 · Inspector's Office *Dec. 17 1929*
District No. *18* County, Va.
Received of *Ben Foster* Captain or Owner
of *Eliz Boyd* hailing from *mother*
Twenty Dollars and Cents,
for violation of the Virginia Oyster Law.
D C Hogge Inspector,
District No. *18* County, Va.
☞ GIVE THIS RECEIPT TO PERSON FINED.

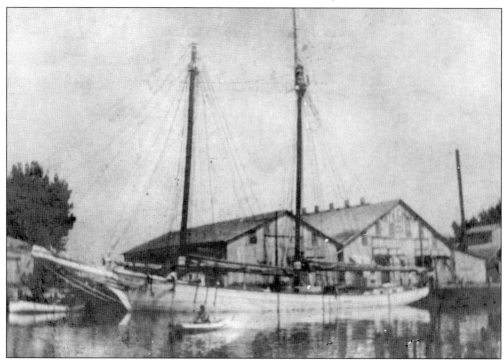

Douglas Soles also hauled freight on a bugeye. Seen docked here, probably at Callis Wharf, the heavily built boat has been admired as the 18-wheel truck of the waterways. Below, Soles posed for this photograph around 1930. The bugeye was an old-fashioned boat by this time, but it was plenty big and sturdy enough to do the job of moving heavy loads. (Both, courtesy of Woody, Nancy, and Ron James.)

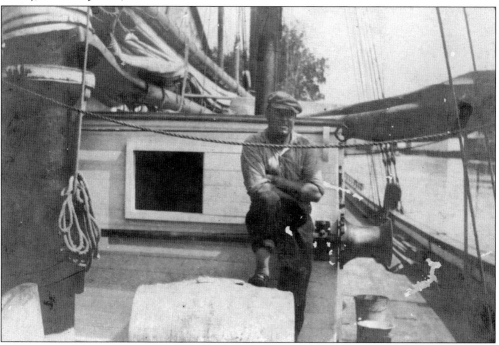

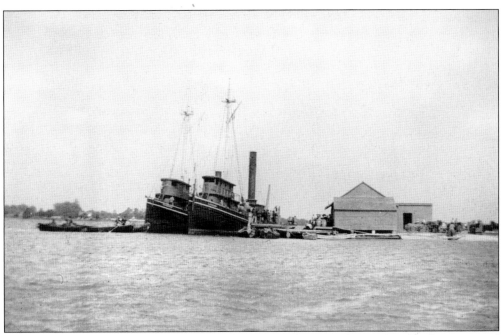

A June 11, 1925, newspaper notice said, "Most of the fishermen have taken up their nets and [gone] fishing." The Atlantic menhaden, also called herring and alewives, was among the most abundant fish in the Chesapeake Bay. They were processed into feed and fertilizer. Purse seines or large nets were used to surround and pull up the catch. As nets closed around them and there was less room, the fish would be corralled so that they could be more easily scooped into the waiting steamer. In the top photograph, menhaden steamers wait at Williams Wharf. At the bottom, a menhaden steamer works in the East River with watermen in smaller boats. The *Mobjack* can be seen at a wharf across the river. (Both, photographs by Herman Hollerith Jr.; courtesy of the Chesapeake Bay Maritime Museum.)

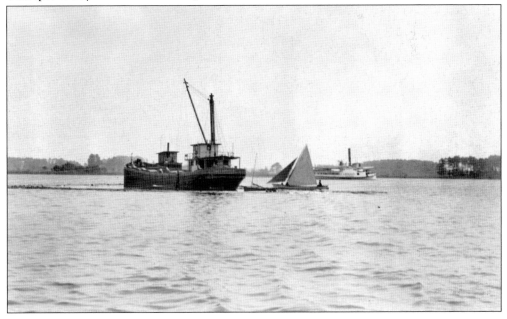

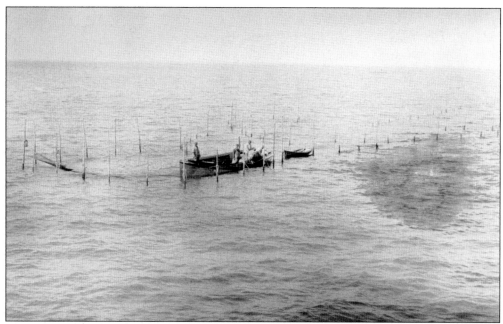

The pound net is a fish trap that diverts fish into the heart of the trap where they cannot get out. Wooden stakes are pounded into the shore bottom, and nets are arranged to corral the fish. To harvest them, watermen in open boats gather up the nets and scoop the fish into the boats. At top, watermen set nets in the East River. At bottom, New Point waterman Lem Hutson's crew pulls in the pound net. According to William Hobson Powell (1898–1972) in his essay "Growing Up on Gwynn's Island," published in 2000 by the Gwynn's Island Museum, Capt. Noah T. Sterling was the first man from the island to set a pound net. He pound fished off Cherry Point at the northwest tip of the island. Powell said, "Hundreds of the Island people resorted to the water as their main livelihood and followed this for many years." (Top, photograph by Herman Hollerith Jr.; courtesy of the Chesapeake Bay Maritime Museum. Bottom, photograph courtesy of Catherine C. Brooks.)

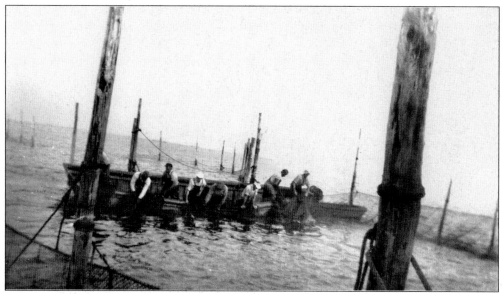

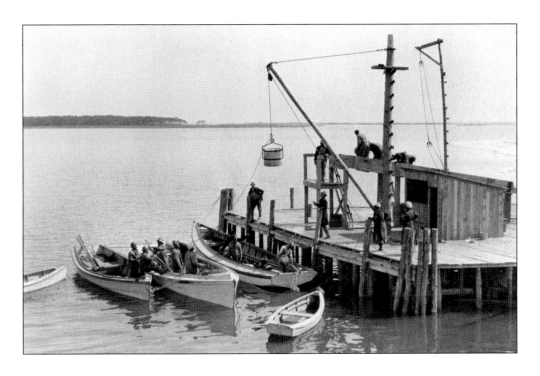

Above, herring are being unloaded at "the cannery," and below, boats loaded with shad come into New Point Wharf. The photographer kept a ledger of cameras he used to take photographs that sometimes noted the activity and location of his subjects, as he did for these. (Both, photographs by Herman Hollerith Jr.; courtesy of the Chesapeake Bay Maritime Museum.)

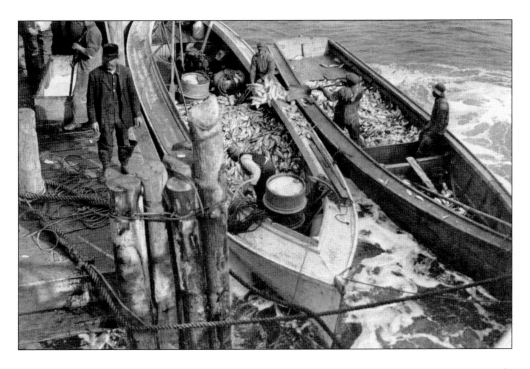

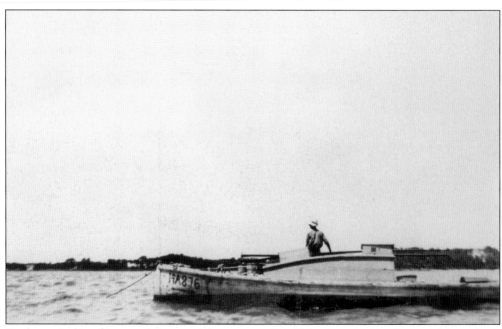

Powhatan Indians harvested oysters with tongs or rakes. Colonists continued to use this method. Later large dredges that raked across the oyster reefs appeared when watermen from other areas moved into the bay. Their methods were quickly adopted here because they were so efficient. By the middle of the 1800s, it was clear that dredges were damaging oyster reefs that took decades, even centuries, to mature. Once laws were tightened concerning when and where oysters could be dredged, some oystermen returned to less destructive methods, as seen in these photographs of Robert James tonging from a deadrise workboat in the mouth of the East River. Watermen who participated in harvests of 1 to 3 million bushels of oysters saw the size of harvests decline because of disease and over-harvesting. By 2000, the annual harvest was about 10,000 bushels. (Top, courtesy of Woody, Nancy, and Ron James. Bottom, courtesy of Wilson Davis.)

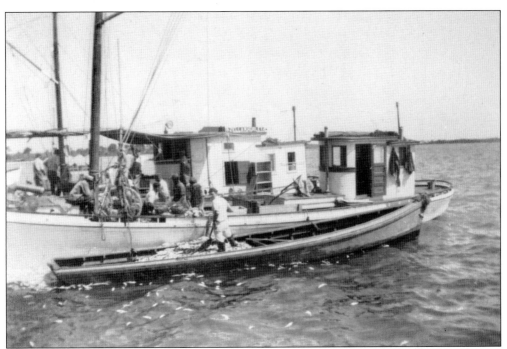

The internal combustion engine took the place of sails. In this 1944 photograph of Sand Bank Wharf at Horn Harbor, the site of Chesapeake Seafood, operated by Walter Garrett through 1970, a waterman is seen transferring his catch to a buyboat. The term buyboat came from the use of boats to purchase oysters, crabs, and fish from watermen and then to haul the seafood to processing houses throughout the region. Some bugeyes were converted from sailing to motorized vessels, and buyboat became a generic name for a vessel involved in moving freight. They were as common on the creeks and rivers then as trucks are on the highways today. Trucks and refrigerated vehicles eventually took over the freight and overland hauling business. The work of a waterman was never easy and was sometimes dangerous. Russell Mitchem, seen here fishing pound nets, lost his life in 1957 when his boat engine exploded. (Top, courtesy of Joice Smith Davis. Bottom, courtesy of the Gwynn's Island Museum.)

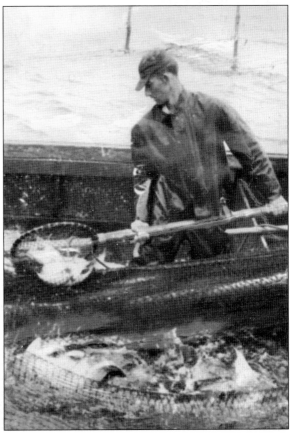

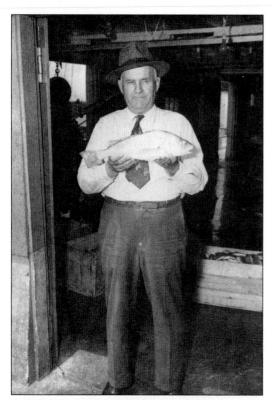

Callis Wharf (opposite) was built by William James Callis and improved by his son E. Eugene Callis. His son, Elwood E. Callis Jr., pictured here, was born in 1895 and ran the seafood business at the wharf. Side-wheeler steamboats that traveled from Baltimore to Freeport Landing on the Piankatank stopped at the Callis Wharf from the early 1900s to about 1936. Callis Wharf became a hub of island seafood business. Picking, shucking, filleting, canning, ice storage, and cooking, as seen below, were daily activities. (Both, courtesy of the Mathews Maritime Foundation.)

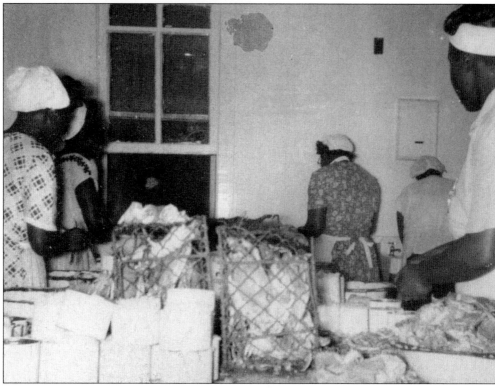

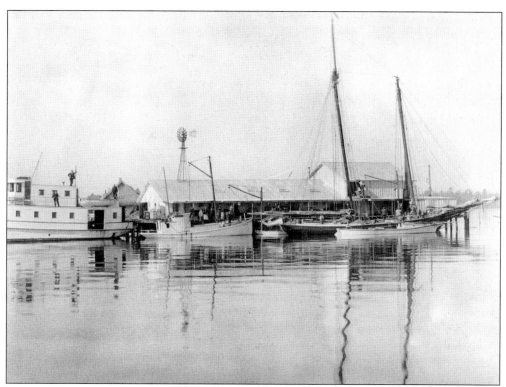

Elwood Callis began work at his father's wharf in 1912 at the age of 17. In his early years, he watched steamboats come and go, in particular the *Piantatank*, a steamer that served the Baltimore-to-Piankatank River route for 20 years. Smaller steam packets, as seen to the left in the photograph of Callis Wharf above, began to out run and under price the large steamboats beginning about 1925. Deadrise workboats and buyboats as well as an earlier bugeye gathered at Callis Wharf at the same time. The deadrise *Maid King*, built in 1921 at Port Haywood and owned by Dorsey Mitchem (seen here), made frequent calls at the wharf where her fresh catch was processed and sold. Another nearby wharf on the steamboat line was Fitchett's Wharf, located across Milford Haven on the point at Billups Creek and Stutts Creek. An early-1800s shipyard, owned by Lewis Hudgins, stood there until Union forces destroyed it in 1864. (Top, courtesy of Mathews Maritime Museum. Bottom, courtesy of the Gwynn's Island Museum.)

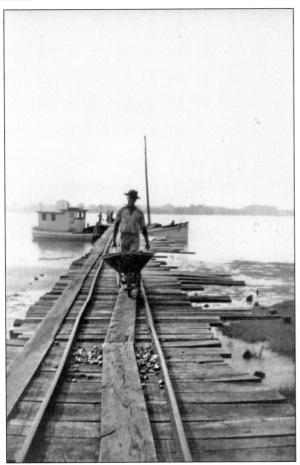

The wharfs and the boats that called on them are fondly remembered. But today, when mechanized and motorized means are almost taken for granted, it is noteworthy to bear in mind that muscle power was the primary means for loading and unloading—for making the connection between land and sea. At left, this photograph prompted Wilson Davis to recall the hard work of loading potatoes and unloading coal by rolling them in wheelbarrows along the family's wharf at Myrtle Grove. At New Point, below, a stream of men with wheelbarrows was needed to load and unload at the commercial location. (Top, courtesy of Wilson Davis. Bottom, photograph by Herman Hollerith Jr.; courtesy of the Mathews County Historical Society.)

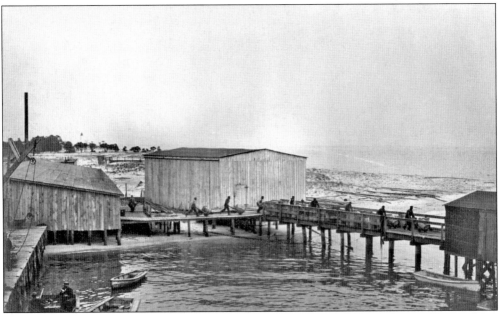

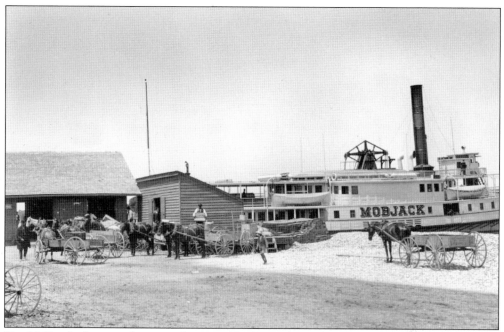

Two Hollerith photographs expose how quickly things changed in Mathews, as they did elsewhere in the Western world after the First World War. The photograph at the top was taken about 1910. Horse-drawn carts are loaded with sacks, crates, and travel trunks as goods and passengers get on and off the steamboat *Mobjack*. It is listed in Hollerith's ledger with other scenic views taken in the earliest years of the family's visits to their new home at Brighton. Hollerith took the photograph at the bottom in 1921, according to his ledger. Cars bring and await passengers traveling on the steamboat *New York*. George Philpotts's fuel depot that supplied his garage in Mathews Court House can be seen to the right. (Both, photographs by Herman Hollerith Jr.; courtesy of the Chesapeake Bay Maritime Museum.)

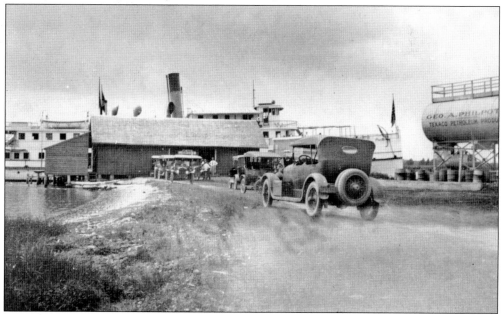

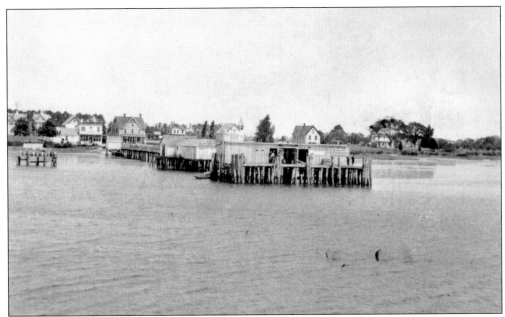

Philpotts Wharf, built by Hesekiah T. Philpotts, was located in the village of Mobjack, where the North and East Rivers meet the Mobjack Bay. This Hollerith photograph was taken from a steamboat traveling up the East River about 1910, nearly 30 years earlier than the photograph of Philpotts Wharf used on the cover of this book. (Photograph by Herman Hollerith Jr.; courtesy of the Chesapeake Bay Maritime Museum.)

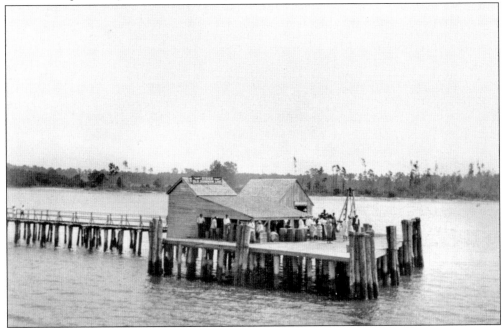

While on the same trip, Hollerith probably took this photograph of Diggs Wharf as well as the photographs above and on the opposite page. Diggs Wharf is located on the east side of the East River almost directly across from Philpotts Wharf. (Photograph by Herman Hollerith Jr.; courtesy of the Chesapeake Bay Maritime Museum.)

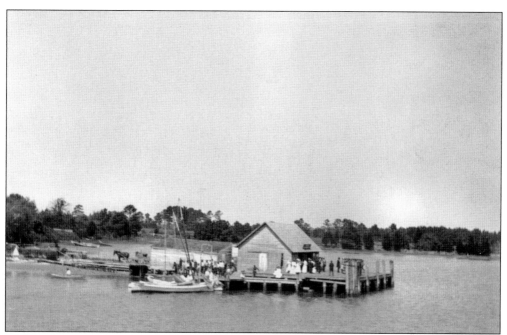

Hicks Wharf was located about five miles north of Philpotts Wharf, on the west side of the East River. It was a convenient spot for farmers from Cardinal to Bohannon to meet the steamboat with their goods. Hicks Wharf was the location of the first post office on the East River in 1869. (Photograph by Herman Hollerith Jr.; courtesy of the Chesapeake Bay Maritime Museum.)

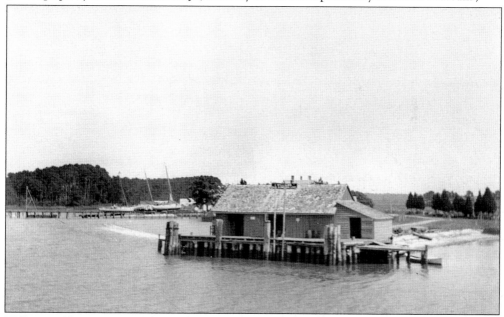

Williams Wharf was Mathews's most central wharf. Goods could be taken to Mathews Court House by cart. In the early 1800s, small barges or lighters may have been used to take goods to the courthouse by way of Put-in Creek, which had its headwaters behind Christopher Tompkins's mercantile store. (Photograph by Herman Hollerith Jr.; courtesy of the Chesapeake Bay Maritime Museum.)

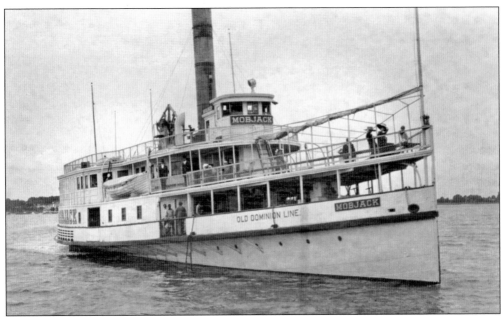

The arrival of the steamer *Mobjack*, seen here approaching Williams Wharf, was greatly anticipated on the East River when she provided rural Mathews with a connection to the city of Norfolk. In 1900, the steamers took four to six hours to travel between Williams Wharf and Norfolk, depending upon the number of intervening stops and direction. A one-way ticket cost $1. (Photograph by Herman Hollerith Jr.; courtesy of the Chesapeake Bay Maritime Museum.)

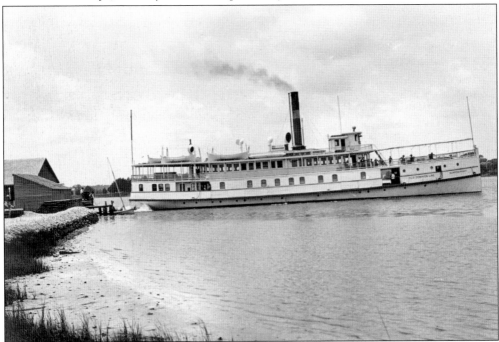

Steamboats first appeared after the War of 1812. The steamer *Hampton Roads*, seen here, was built in 1896 and plied the waters between Norfolk and Mathews around 1920. (Photograph by Herman Hollerith Jr.; courtesy of the Chesapeake Bay Maritime Museum.)

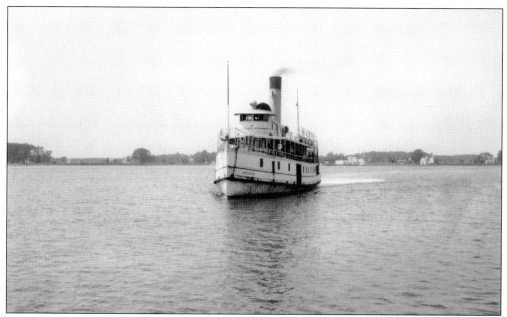

Other steamers such as the *General Mathews* ran between the East River and Norfolk in the 1920s. Of steamboats, William Hobson Powell said, "When I think of the passing of these steamers and no more landing on the rivers as in those days there's a sadness and longing that can never be overcome. The old river boat and the river meant so much to everyone in those days." (Photograph by Herman Hollerith Jr.; courtesy of the Chesapeake Bay Maritime Museum.)

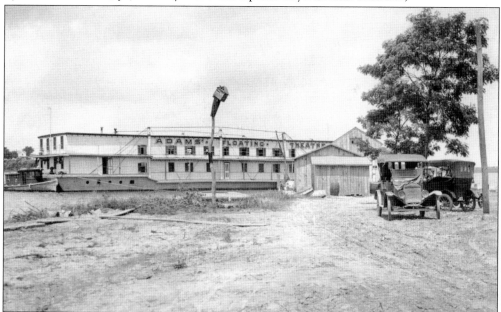

The James Adams Floating Theatre, seen at Williams Wharf in this 1920 photograph, traveled to towns around the Chesapeake Bay from 1914 to 1941. The floating theater was an important cultural resource for people in small coastal towns. It inspired the novel *Showboat*, which became a hit Broadway play in 1927. (Photograph by Herman Hollerith Jr.; courtesy of the Chesapeake Bay Maritime Museum.)

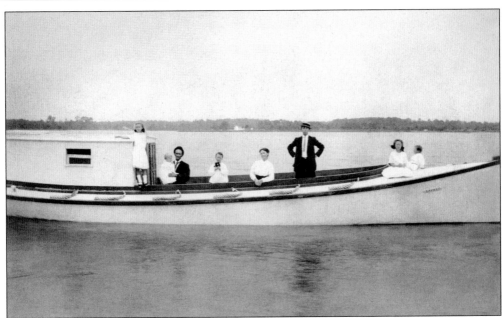

Until the advent of automobiles and highway systems, boats offered the main form of transportation and were vital to farmers and fishermen. They were also vital to every family in the same way that a car is necessary for transportation today. Before the ferry from the mainland to the Mathews community of Gwynn's Island, the only way to cross the water was by boat. In 1912, the Thomas Elliot Edwards family traveled on their boat, the *Savage*. Pictured from left to right are Alice (James), Edwards holding Charles, Henry, Mrs. Edwards, Elliot, Lucy (Deagle), and Curtis. Below, a group of people crossed the East River to attend a church meeting. (Top, photograph courtesy of the Gwynn's Island Museum. Bottom, photograph by Herman Hollerith Jr.; courtesy of the Chesapeake Bay Maritime Museum.)

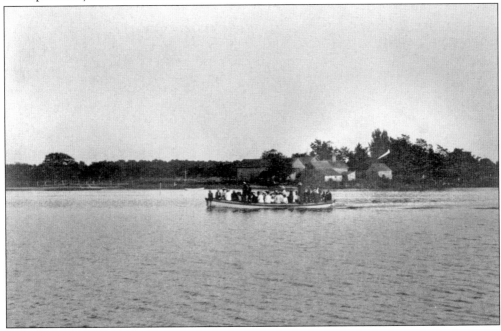

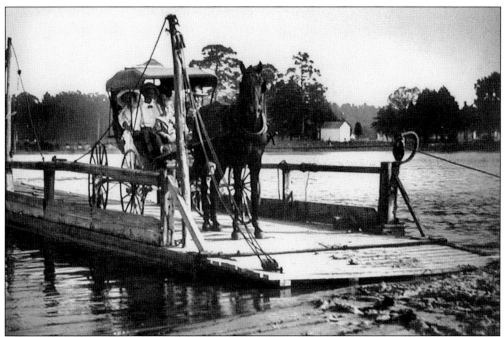

In 1885, a cable ferry was built between Gwynn's Island and the mainland that required a man to pull the cable. Later a motor was used to power a small ferry. The Gwynn's Island Bridge was built in 1939. To get from northwest Mathews to Middlesex County, travelers had to use Twigg's Ferry. Anyone traveling from the north to Mathews would use this route. The top photograph on the Gwynn's Island Ferry was taken in 1912, and the bottom one of Twigg's Ferry was taken around 1920. (Top, photograph by Percy E. Budlong; courtesy of the Gwynn's Island Museum. Bottom, photograph by Herman Hollerith Jr.; courtesy of the Mathews County Historical Society.)

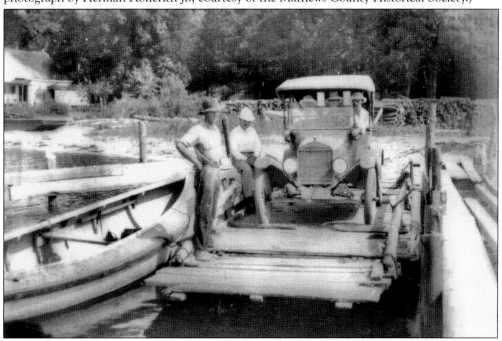

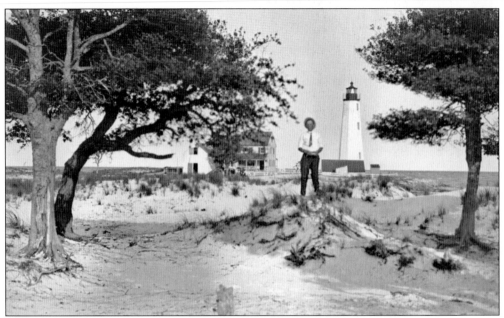

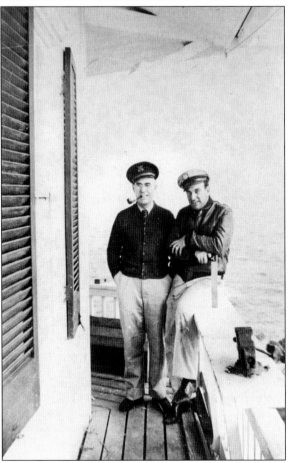

Lighthouse keepers tended oil lanterns that sent out beams of light to warn sailors off of the Chesapeake Bay's shoals. The New Point Lighthouse was authorized in 1801, but just over 100 years later, the lighthouse keeper's house was taken down, and by 1930, the light was partially automated. The sandy neck of land was breeched by storms that have completely washed the beach away. The sturdily built column is reinforced today. Screwpile lighthouses were more common from the late 1800s to mid-1900s. Frank R. Lewis Sr. (1894–1959), with the pipe, and his assistant, Aubrey Hudgins, sitting on the rail, posed for this photograph while on Stingray Point about 1945. (Top, photograph by Herman Hollerith Jr.; courtesy of the Chesapeake Bay Maritime Museum. Bottom, photograph courtesy of Frank Raymond Lewis Jr.)

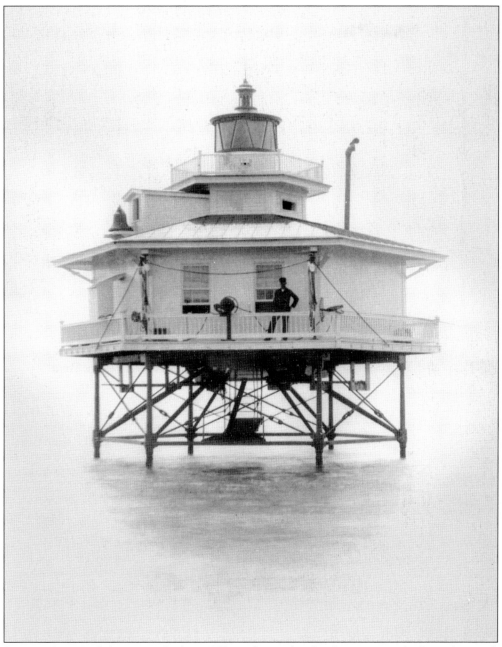

Stingray Point Lighthouse was built in 1858 on the south side of entrance to the Rappahannock River. Levi D. Marchant (1854–1943) of Mathews was keeper for 32 years, one of the longest tenures for a lighthouse keeper on one lighthouse on the bay. His replacement on the lighthouse was Lewis, pictured opposite; his grandmother and Marchant were first cousins. The lighthouse was automated in 1949. (Courtesy of the Gwynn's Island Museum.)

The wharfs and waterways were the backdrop for gatherings of Mathews's families and friends. This photograph's owner believes that it was taken around 1905. Included in the photograph are Ellis White, Eva White, Davis's Grandma Berta and Aunt Frankie, and Maurice Davis, who use the rail dolly at the end of the warehouse dock as a seat. (Courtesy of Wilson Davis.)

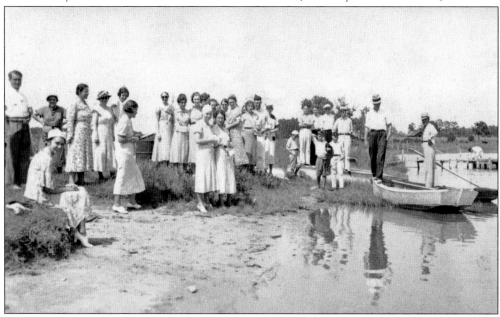

Young people from the Hampton Roads District Evangelical Friends Churches enjoyed a Garden Creek area beach while meeting at the open-air tabernacle during the last week of July from the mid-1930s to the early 1940s. Wilbur C. Diggs, pastor of Peniel Friends Church, administered the camp. Youth from Newport News, Portsmouth, Achilles, and New Point churches attended. (Courtesy of Catherine C. Brooks.)

New Point, at the southernmost tip of Mathews, provided residents with the best sand beach in the county and sweeping views across the Mobjack and Chesapeake Bays. A portion of the beach area, which became a Boy Scout camp later, was used by the military for training during World War II. During a Scout picnic in the 1950s, Joice and Florence Smith, center, took advantage of New Point beach with four of their younger nieces and nephews. (Courtesy of Joice Smith Davis.)

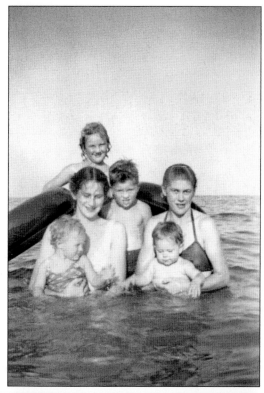

The Mathews Yacht Club on Stutts Creek, founded in 1949, has been the scene of neighborly get-togethers for generations of Mathews families and "come-heres" who enjoy nothing better than "messing about in boats," as Rat said to Mole in *The Wind in the Willows* by Kenneth Grahame. (Courtesy of Catherine C. Brooks.)

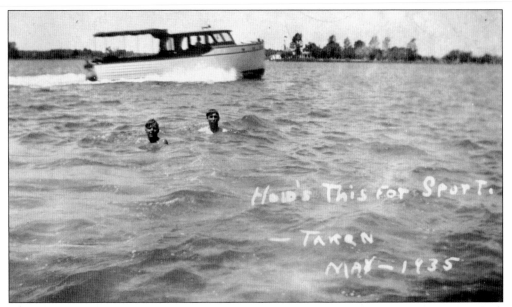

This photograph of boys enjoying a swim in the East River was taken in May 1935 near Tick Neck. It is inscribed, "How's this for sport?" A motorboat speeds away behind the swimmers. (Courtesy of Catherine C. Brooks.)

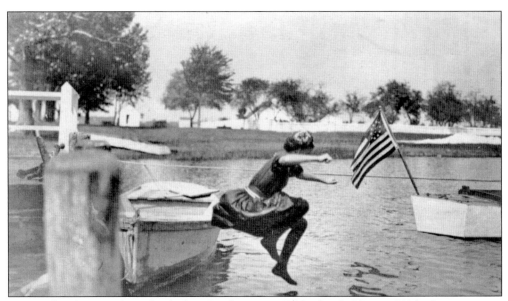

Nan Hollerith jumps from the dock at Brighton into Tabbs Creek. Her *c.* 1910 bathing costume includes a dress and stockings. (Photograph by Herman Hollerith Jr.; courtesy of the Mathews County Historical Society.)

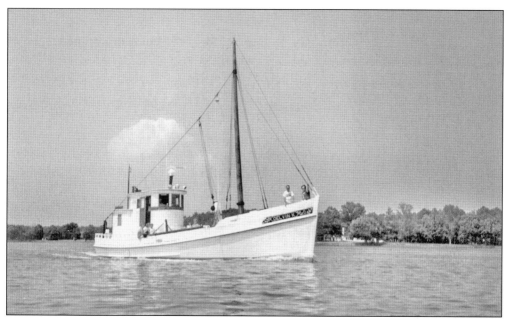

The buyboat *Delvin K* was built at Smith's Railway in Horn Harbor. When Capt. Garnett Godsey owned the boat, he worked from Davis Creek. Seen here operated as a pleasure boat, the *Delvin K* was last known to be plying Maryland waters. (Courtesy of Wilson Davis.)

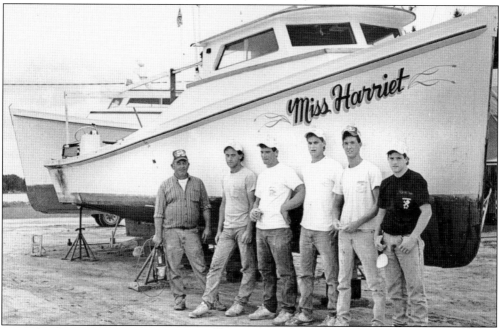

In 1992, Gwynn's Island watermen readied for Norfolk Harborfest workboat races. Smith family owners and crew members of the *Miss Harriet*, *Island Pride*, and *Pamela J.* include, from left to right, Donnie Smith and his sons, Lee and Todd, Tracey Smith, Jimmy Hunley, and Tristan Judson. The *Island Pride* was a boat parade winner in 1991, and the *Pamela J.* won several previous races. (Photograph by Virginia Ward; courtesy of Tidewater Newspapers, Inc., and the Gwynn's Island Museum.)

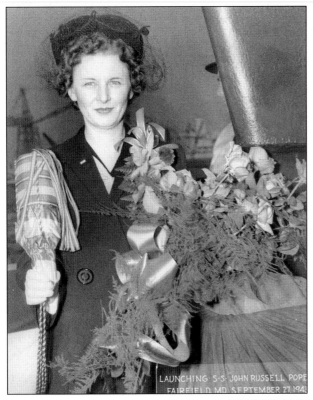

LAUNCHING S.S. JOHN RUSSELL POPE
FAIRFIELD, MD. SEPTEMBER 27, 1943

Mathews men served in the world wars in all branches, but their service in the navy and Merchant Marine is legend. An oft-repeated saying claims that a Mathews man could find another man from Mathews at any port in the world. Mrs. Melvin (Eleanor) Respess, whose husband was lost at sea during World War II, was invited to christen the SS *Pope* at the Baltimore Shipyard because so many men from the county, including her husband, were lost at sea. Other victims of enemy submarines include Capt. George Dewey Hodges, Second Officer Genius Hudgins Jr., Vernon Emmett (Billy) Davis Jr., and William Hammond. Below, Homer Verdayne Callis (1923–1945), son of Homer and Nancy Callis of Grimstead, was lost at sea on the destroyer USS *Hazelwood*. (Both courtesy of the Gwynn's Island Museum.)

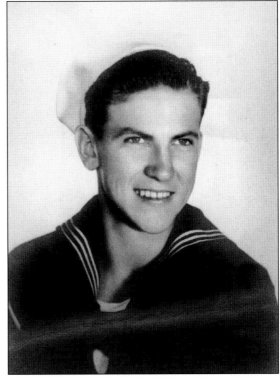

Cmdr. Hugh M. "Dixie" Godsey, son of Richard and Alice Godsey and husband of Anny K. Carman, served in the U.S. Naval Reserve during World War II on the escort vessel USS *Johnny Hutchins*. He returned to Gwynn's Island to live until his death in 1975. (Courtesy of the Gwynn's Island Museum.)

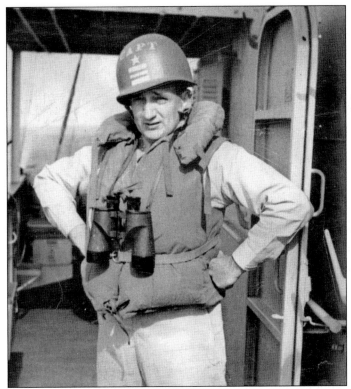

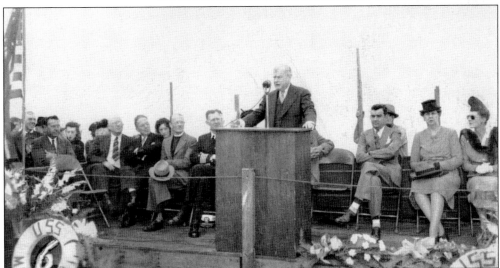

On Mathews Day in 1946, U.S. representative S. Otis Bland of Newport News eulogized Mathews County mariners at a memorial service held at Hudgins Bay Shore on Gwynn's Island. On the platform were, from left to right, board of supervisors chairman James A. Hatch; Rev. Junius E. Foster, pastor of Mathews Baptist Church; Rev. S. Janney Hutton, rector of Kingston Episcopal Parish; Capt. A. G. Gaden, U.S. Navy, captain of the USS *Mathews*; former delegate James Bland Martin of Gloucester; Mrs. S. Otis Bland; and Mrs. James Bland Martin. Seated behind S. Otis Bland is Virginia delegate John Warren Cooke of Mathews, who presided. (Courtesy of Tidewater Newspapers, Inc.)

The Mathews waters have not always smiled on the county's citizens. During the winter of 1779–1780, the Chesapeake Bay froze solid as far south as New Point Comfort. In 1917–1918, boats did not travel between Baltimore and Norfolk for 30 days while the bay was frozen. This photograph was taken of the Chesapeake Bay off of Gwynn's Island during the coldest winter there in the 20th century. (Courtesy of the Gwynn's Island Museum.)

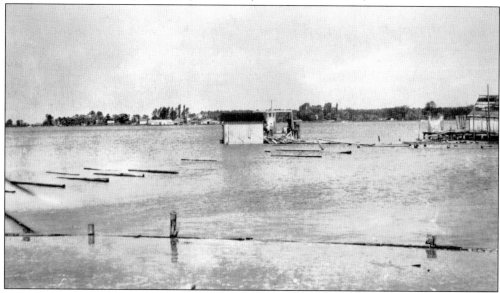

In 1788, the George Washington hurricane passed over the area. Winds tore down trees, and many in Mathews saw their houses flooded. On August 22, 1933, winds increased and rain fell. Mathews County's creeks and rivers rose, and a swell approximately 12 feet high surged over land. The wall of water swept over livestock, crops, boats, and houses. In 2003, Hurricane Isabel felled trees and flooded houses again. (Courtesy of the Gwynn's Island Museum.)

Six

CENTERS OF
COMMUNITY LIFE

As post–Civil War Mathews County grew, its population organized by access to schools, churches, post offices, and stores that were within convenient walking distance. Families were generally large, and plat books at the Mathews County Circuit Clerk's Office illustrate that these walkable units were made up of a few surnames each. Communities grew as families divided their holdings of land and passed them down to the next generation.

Although Thomas Jefferson introduced public education to Virginia, the first record of a public school in Mathews appeared nearly three-quarters of a century later, in 1871. Public schools included Milford Haven, Winter Harbor, New Point, and Cobbs Creek. Private schools were established in neighborhoods by parents and interested citizens according to the need for a school within walking distance. These private schools often reflected the expectation that the races should be segregated. Rural education was seen as a part-time experience. Going to school could not interfere with the more pressing seasonal demand for labor in the agricultural area.

Churches and schools sometimes developed hand in hand. Often the availability of the school meant that there was a building in which to hold services on Sunday or vice versa. Methodist and Baptist churches were predominant in the 19th century. After the Civil War, Mathews Baptist Church at Hudgins, which had been integrated, helped create a separate church for African Americans. Other churches for white congregations were established from Old Baptist, which was founded soon after the Revolution.

Walk with Me, by Catherine C. Brooks, is recommended reading for those who wish to understand the development of Mathews County community by community. Brooks explains, "The isolated general merchandise store, where a post office sat in the corner, became the center of each community. . . . The business not only furnished groceries . . . but social life for the residents. Their other contact with each other was at Sunday worship services, but this split the communities into groups."

Many short booklets are available from the Gwynn's Island Museum for those interested in further reading about Mathews County's unique communities. These booklets, which include reminiscences of early citizens, provide a window into the early mind of Mathews.

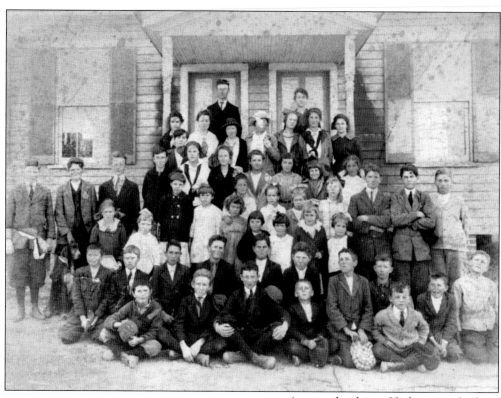

A new school near Hudgins was built about 1905. This 1914 photograph of Cattail Branch Academy shows that nearly 50 children attended the school north of Stutts Creek and along Cricket Hill Road. Dorothy Powell Hudgins stands in the center with her hand on the shoulder of the child in front of her. Nell Powell Callis stands in the last row, second from the left, wearing a dark-colored scarf. (Courtesy of Diana Hudgins Swenson.)

"*Fitting Ourselves for Service.*"

Mathews Academy
and
Westville Public School.

Announcement: 1906.

Re-opens Monday, Jan. 3, 1906.

At 9 o'clock A. M.

Academy Board:

Capt. ALEX. JAMES, Chairman;
S. E. RICHARDSON, Esq.; J. F. MARCHANT, Esq.;
G. S. MARCHANT, Esq;
JOHN J. BURKE, Esq., Sec.-Treas.

Public School Board:

GEO. W. MASON, Esq., Chairman;
R. B. GAYLE, Esq.; WALTER R. STOAKES, Esq., Sec.

A 1906 announcement suggests a partnership between private and public schools to be a convenient arrangement during the early years of public education. (Courtesy of Diana Hudgins Swenson.)

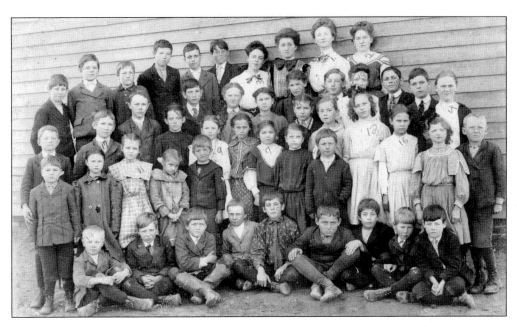

A later owner of this 1910 photograph of children attending school in Bohannon wrote the names of students that he or she could identify on the back. Included were Martha Minter, Baby White, Pearl Adams, Linda Steiger, Charlie Hill, Mabel Bassett, Erma Mickelborough, Cora Adams, Bessie Raines, Robert Hudgins, Bertha Thomas, Goldie Miles, Clara Glen, Hilton Greene, Bernice White, Evelyne Foster, Holland White, Ernest White, and Edith Morgan. The old Peninsula School at Bohannon (below) is used today as the West Mathews Civic Center. (Top, courtesy of Ralph Anderton and the West Mathews Civic Center. Bottom, courtesy of Woody, Nancy, and Ron James.)

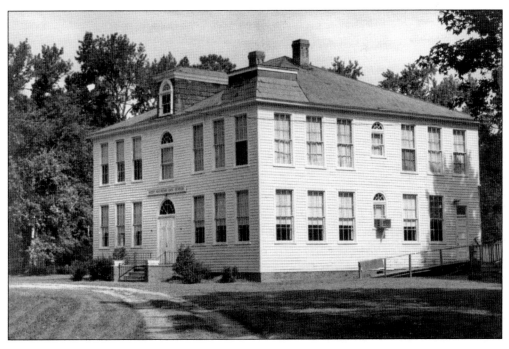

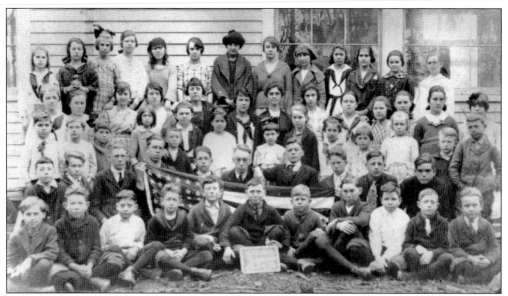

Winter Harbor School was also called Pine Grove Academy. Since most of the large oak trees had been used to build ships or buildings or had been burned for fuel, the secondary growth of pine trees gave the area its name. (Courtesy of Tidewater Newspapers, Inc.)

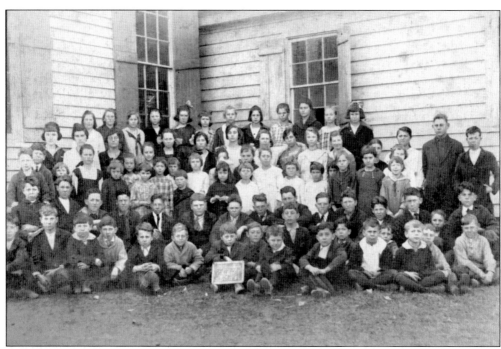

At Milford Haven School, all six grades used the three-room schoolhouse. After sixth grade, students went to Lee-Jackson High School. This photograph was taken of the 1914 student body. (Courtesy of Catherine C. Brooks.)

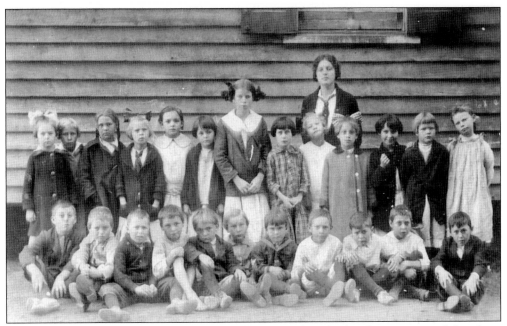

This 1916 photograph of Eleanor Respess and her second-grade class hangs in an exhibit about early education at the Gwynn's Island Museum. First graders are also pictured. Nanny Hatch taught both classes. (Courtesy of the Gwynn's Island Museum.)

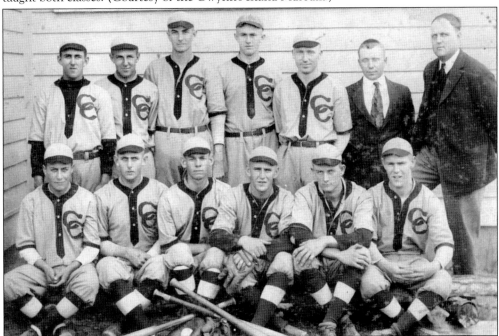

The 1921 Cobbs Creek baseball team included from left to right (first row) Eddie Fitchett, Marvin Mathews, Floyd Bennett, Lumpkin Soles, James Hatch, and F. L. Joslin; (second row) Floyd Thompson, Curtis Fitchett, Coles Edwards, Max Winder, Thomas Davis, and Eldridge Winder. H. W. Garrett, principal, stands on the right end in the back row with the team. (Courtesy of Tidewater Newspapers, Inc.)

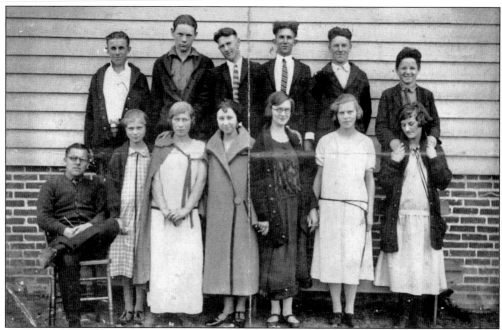

In 1922, a new high school opened on Gywnn's Island. The class of 1924 included from left to right (first row) Stanley Armistead, Ruby Hudgins, Florence Godsey, Bunie Mitchem, Eleanor Powell, Eleanor Hudgins, and Virginia Williams; (second row) Henry Rowe, Avery Ward, Leonard Callis, George Fitchett, Curtis Edwards, and Tommy Loop. (Courtesy of the Gwynn's Island Museum.)

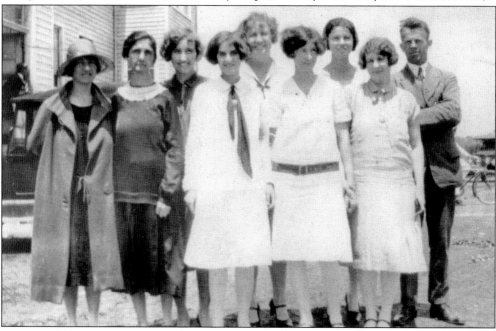

The New Point High School faculty, photographed in 1927, included, from left to right, Fannie Brooks Hudgins, Daisy Diggs, Elsie Tomlinson Hudgins, Renell Norton Hudgins, Susie Brooks Clarde, Bernice Rowe White, Lillian Powell Diggs, Maude Clements Pritchett, and Lester L. Smith, principal. (Courtesy of Tidewater Newspapers, Inc.)

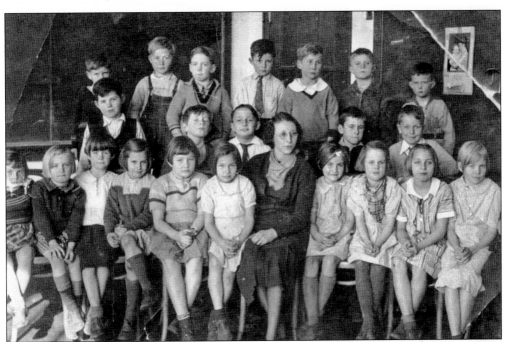

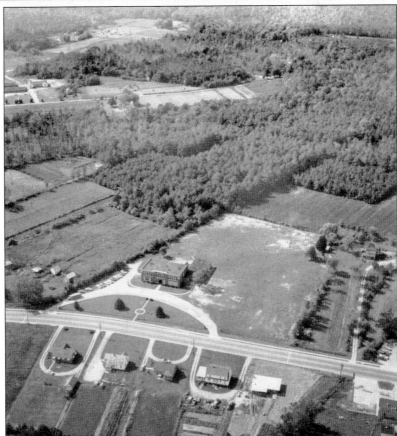

Marion Diggs was the teacher of this class at Lee-Jackson School in 1935. An aerial photograph of the school was taken around 1960. (Top, courtesy of Catherine C. Brooks. Bottom, photograph by Walter G. Becknell; courtesy of the Gwynn's Island Museum.)

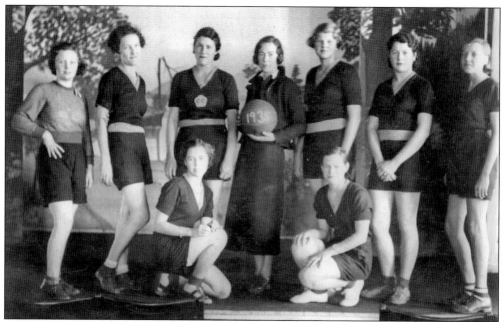

The 1935 women's basketball team at Cobbs Creek High School was artfully posed for this photograph. Indoor flash photography had arrived by this time, and professional photographers often used background screens decorated with outdoor scenes. (Courtesy of Woody, Nancy, and Ron James.)

Elementary school children at Cobbs Creek danced around the maypole. This photograph was taken by or for teacher Vivien Garrett, whose uncle, Hunter Garrett, was the school's principal. (Courtesy of Woody, Nancy, and Ron James.)

At Gwynn's Island School, the 1948 May Queen was Jane Lee Forrest Smith, seen here surrounded by her court. Fannie Diggs was May Queen at Thomas Hunter School in 1948. Because May Day was associated with the workers' rights riots and communism, the celebrations went out of fashion in the 1950s and were replaced in the public schools by athletic field days, Earth Day, and other celebrations of spring. (Top, courtesy of the Gwynn's Island Museum. Bottom, courtesy of Antioch Baptist Church.)

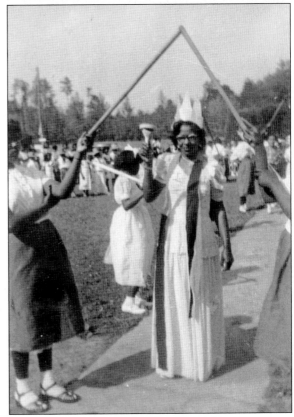

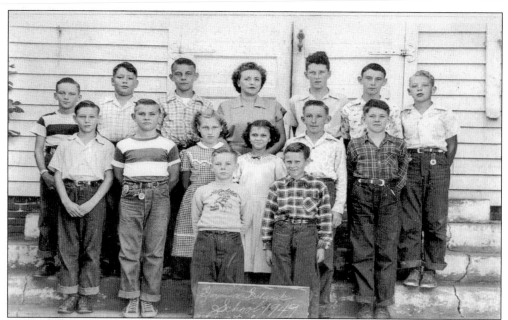

In 1949, the sixth- and seventh-grade classes at Gwynn's Island School were photographed surrounding longtime and beloved Mathews teacher Josephine Brown Blaney. Included from left to right are (first row) Graydon "Grady" Powell and James "Jimmy" Williams; (second row) Everett Darden Brown, Gerald Rowe, Kathryn Ward Drummond, Lavenia "Sis" Callis Thomas, Maurice "Teeny Boy" Crockett, and Gary Wayne Ogden; (third row) Nowell Loop, Emerson Jackson, Edwin Carroll Forrest, Josephine Brown Blaney (teacher and principal), Robert Sparrow, John "Junie Buck" Buchanan, and Tilden "T. W." Hudgins. (Courtesy of the Gwynn's Island Museum.)

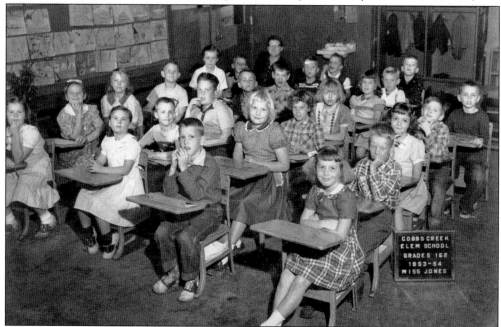

Miss Jones taught this group of first- and second-grade students at Cobbs Creek Elementary School in 1953 and 1954. (Courtesy of Woody, Nancy, and Ron James.)

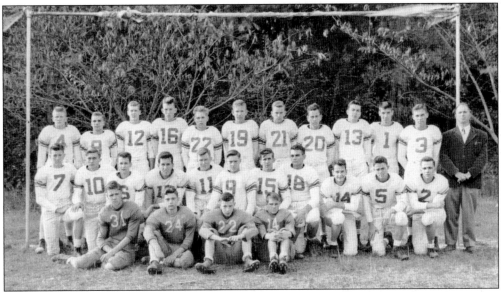

Ken Brown founded the football program at Mathews High School. Pictured with the team on November 16, 1950, are, from left to right, (first row) Fred Tomlinson, Sonny Tucker, Jerry Buckner, and Hugh Jordan; (second row) Bobby James, Jack Ellingsworth, Grady Spry, Frank Davis, Stephen Mitchem, Morgan Pritchett, Herbert Figg, Donald Morgan, Larry Spry, Jimmie Smith, and Jimmie Stewart; (third row) Joe Crewe, Harry Lewis, Stanley Brownley, John Machen, Carey Hunley, Edwin Haufler, Allen Callis, James Adams, Bud Dunton, Lindy Hurst, Leslie Callis, and Ken Brown. (Courtesy of Tidewater Newspapers, Inc.)

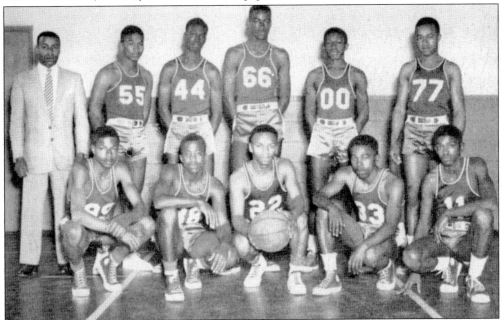

Mr. Wallace coached the basketball team at Thomas Hunter School in 1954. Team members included, from left to right, (kneeling) Winston Johnson, Johnny Weston, Donell Wormley, Thomas White, and Milton Spriggs; (standing) Ellis Brown, Robert Thomas, William Spriggs, Shelton Foster, and Calvin Singleton. (Courtesy of Antioch Baptist Church.)

The Mathews High School third-year home economics class visited the Miller and Rhoads tea room in 1959. Attendees were, from left to right, (seated) Jane Stoddard, Mary E. Diggs, Mary A. Mickelborough, Betty Y. Edwards, Betty Hudgins, and Faye Hutchinson; (standing) Janet Haynes, Mary E. Godsey, Daphne Pritchett, Ruth Bentsen, Carol Dow, Mary Dillehay, and Rebecca Winder. (Courtesy of Tidewater Newspapers, Inc.)

Safety Patrol members acted as crosswalk guards, stopping traffic for children who walked to their neighborhood schools. The New Point Safety Patrol included, from front to back, Carolyn Hudgins, Diane Forrest, Joe Diggs, Tommie Owens, and Billy Diggs. The aerial view of New Point School was taken in 1969. (Both, courtesy of Tidewater Newspapers, Inc.)

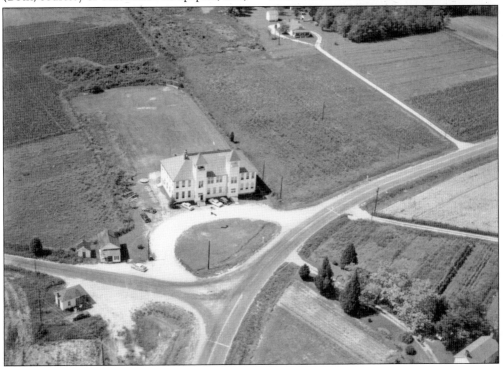

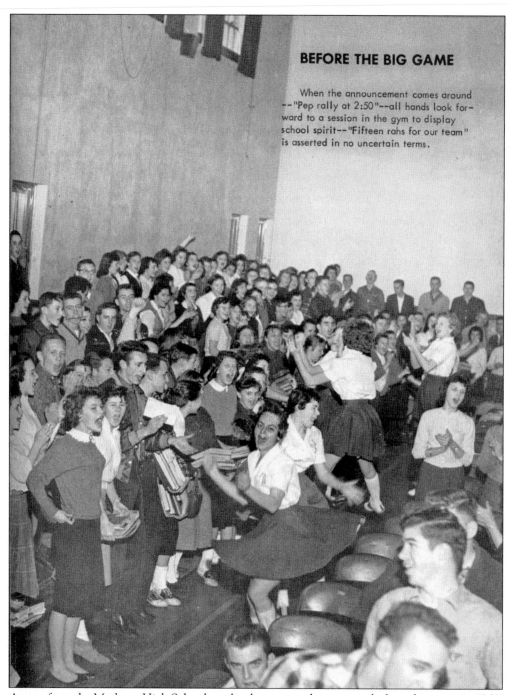

BEFORE THE BIG GAME

When the announcement comes around --"Pep rally at 2:50"--all hands look forward to a session in the gym to display school spirit--"Fifteen rahs for our team" is asserted in no uncertain terms.

A page from the Mathews High School yearbook captures the moment before a big game in 1960. The cheerleader in the center with the twirling skirt is Nan Lee Watkins, and Suzanne Dillehay is directly behind her. To the far left, Eloise Lewis cheers with gusto. (Courtesy of Woody, Nancy, and Ron James.)

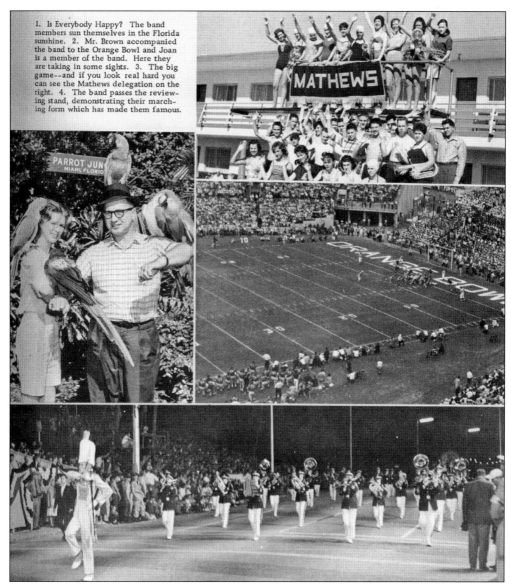

1. Is Everybody Happy? The band members sun themselves in the Florida sunshine. 2. Mr. Brown accompanied the band to the Orange Bowl and Joan is a member of the band. Here they are taking in some sights. 3. The big game--and if you look real hard you can see the Mathews delegation on the right. 4. The band passes the reviewing stand, demonstrating their marching form which has made them famous.

The 1961 Mathews High School yearbook featured scenes from the Orange Bowl. Drum major Bill Foster, bottom, led the band. H. K. Brown and his daughter Joan attracted the parrots. (Courtesy of Woody, Nancy, and Ron James.)

Dr. Lyman B. Brooks of Blakes presided over Norfolk State University from 1938 to 1975. His brother, J. Murray Brooks, was a teacher, principal, and administrator in Mathews and York Counties. The Brooks brothers attended elementary school in Mathews and high school in Middlesex because Mathews had no secondary schools for black students when they were young. (Courtesy of Tidewater Newspapers, Inc.)

A composite photograph was made of each graduating class from Thomas Hunter High School. A drawing of the school building located on Church Street near Mathews Court House, now used as a county-wide middle school, appears in the center. (Courtesy of Tidewater Newspapers, Inc.)

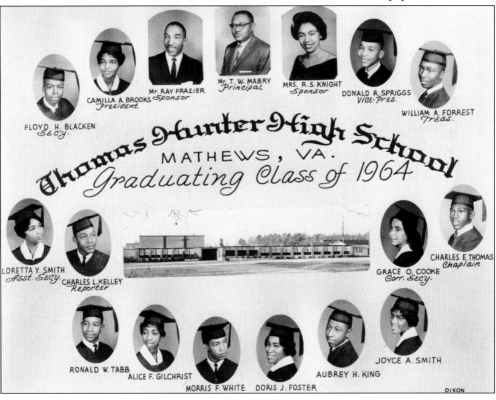

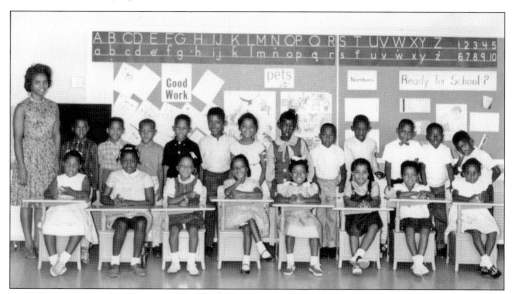

In 1960, six years after *Brown v. Board of Education* and nearly 100 years after the Civil War and the subsequent development of public schools, Mathews public schools were still segregated. The top photograph shows first graders at Thomas Hunter School, and the photograph at the bottom, taken in the same year, is of students at Lee-Jackson Elementary School. The systems were fully integrated within the decade. Lee-Jackson student names written by a child on the back of the photograph include, from left to right, (first row) Bobby, Walter, Lee, Audrey, Ricky, David, Vicky, and Mary C.; (second row) Charles, Cathy, Gwen, Mary Alice, Stanley, Mary Lou, David, and Velvet; (third row) Miss Bessie, Becky, Norma, Tommy, Linda, Mary Bell, Gary, Louis, and Neena. (Top, courtesy of Tidewater Newspapers, Inc. Bottom, courtesy of Joice Smith Davis.)

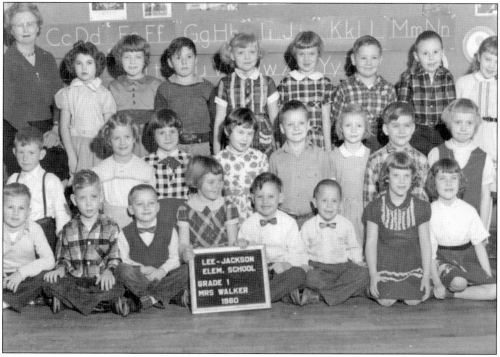

During American Education Week in 1978, Dianne Lee's kindergarten class studied Native Americans. From left to right are (first row) Troy Gwynn, Shelia Johnson, Jessica Stubbs, Stevie Buchanan, and Jessica Bucci; (second row) Michael Tullos, Kenneth Burroughs, Beth Armistead, Amy Robins, Chris Adams, and Catherine Tatterson; (third row) Buddy Kosbeil, Debra Ellen Brooks, Holt Ripley, Deborah Hayes, Daniel Ball, and Tommy Downs. (Courtesy of Tidewater Newspapers, Inc.)

Mathews High School hosted its first regatta in 1989. The third division boys' eight crew had the fastest time of the day in the Second Annual Regatta at Williams Wharf in 1990. (Courtesy of Tidewater Newspapers, Inc.)

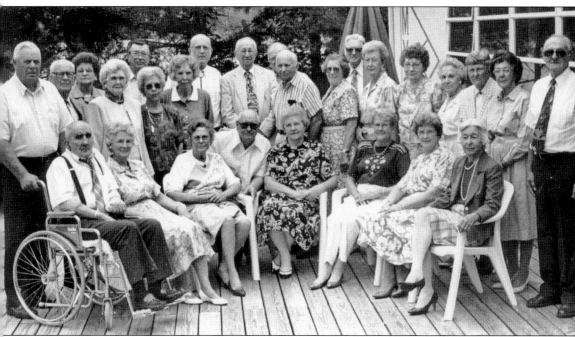

In 1994, the first graduating class from Mathews High School celebrated its 54th class reunion at the Mathews Yacht Club. Members of the 1940 class and teachers attending were, from left to right, (first row) Delbert Hundley, Lorrain Hurst Holland, Virginia Lloyd Robbins, Caroline Bradshaw Bemet, Lucy Smith Groome, Ann Williams Hudgins, and Lillie Shipley Bass; (second row) Elton Hudgins, Jean Palmer Edwards, Laura White Ward, Mary Anna Forrest Cannon, Arnold ("Jimmy") Hudgins, Norma Eirksen, Catherine Heilman Turner, Alva Taylor Brann, Hilda Proctor Callis, Mary Philpotts Hudgins (teacher), Maxine Crockett (teacher), Gloria Diggs, and Allen Brownley; (third row) C. E. Kline (teacher), Kathleen Forrest Garnand, F. Raymond Lewis, Robert Hughes, Tom Emory (teacher), Pete White, and Wallace Braman. (Courtesy of Tidewater Newspapers, Inc.)

In the earliest days of English settlement, the church provided a true sense of community. By law, the church was bound to provide for the community by making available social and civil services and by constructing roads and bridges. Kingston Parish had three churches or chapels: one on the North River, one near Queen's Creek, and one on the East River. A 19th-century Mathews County plat book includes illustrations of Christ Church on "Pudding" Creek, or Put-in Creek, a tributary of the East River and Trinity Church at the river's headwaters near Foster. (Both, courtesy of the Mathews County Circuit Clerk's Office.)

The formation of Mathews Baptist Church came about as part of the countrywide Great Awakening, a period of revival and religious fervor that preceded the political upheaval of the American Revolution. Iverson Lewis of King and Queen, who had cousins in the area, is credited with impressing the faith on others through revivals he conducted in the early 1770s. This led to the formation of Kingston Church, which became Mathews Baptist Church after the county was formed. In 1858, there were 355 white and 445 black members. (Photograph by the author.)

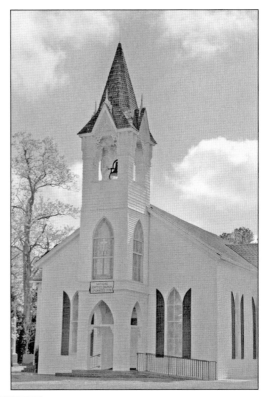

First Baptist Church was founded in 1865 and was the first sanctuary for blacks in Mathews. In 1874, growth in converts and the inconvenience of travel caused three more white churches to be formed: Gwynn's Island, Spring Hill, and Westville. Macedonia was formed from Mathews Baptist Church in 1886. Other Baptist churches for African Americans, such as Emmaus, dedicated in 1867 in North, were also formed. (Courtesy of Antioch Baptist Church.)

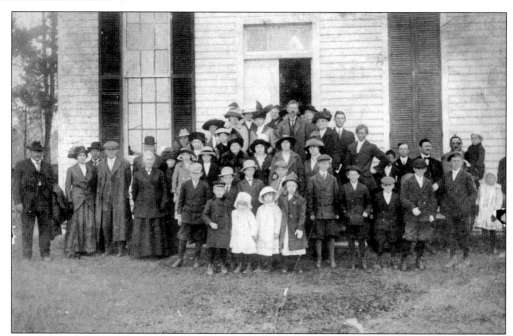

A large crowd gathered in front of Spring Hill Church in 1913 for this photograph. Earlier, in 1874, Elders James G. Council, W. W. Wood, and Richard A. Fox invited "Members living remotely from Ebenezer and Mathews Baptist churches, and others acting in the fear of God and with a desire to promote his glory" to join them at Spring Hill. (Courtesy Woody, Nancy, and Ron James.)

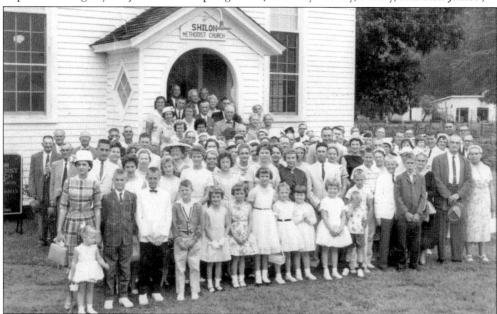

The Methodist church also enjoyed an increase in membership. The congregation of Shiloh United Methodist Church on Gwynn's Island gathered for this photograph around 1955. As travel became easier, lessening the need for churches in every neighborhood, Shiloh merged with Mathews Chapel in the 1970s. Today the original church building is used as the Gwynn's Island Civic Center. (Courtesy of the Gwynn's Island Museum.)

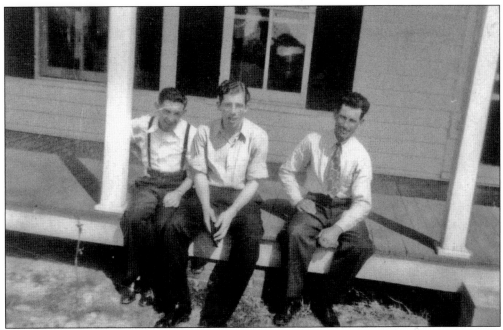

The Peniel Friends organized in 1919 with an emphasis on evangelism and cleansing of the heart. They built a church at Laban the next year. Two students from the Cleveland Bible College (left) met with Maywood Callis (right) when they came to Mathews for a revival during their 1947 spring break. (Courtesy of Catherine C. Brooks.)

Antioch Baptist Church services were held first in a crude log cabin built by newly freed slaves. The congregation is seen here in front of their third church structure. It is located across the street from a Rosenwald school building that was built as part of the Julius Rosenwald Fund initiative to improve public education for African Americans in the early-20th-century South. Between 1912 and 1932, the program produced 4,977 new schools. (Courtesy of Antioch Baptist Church.)

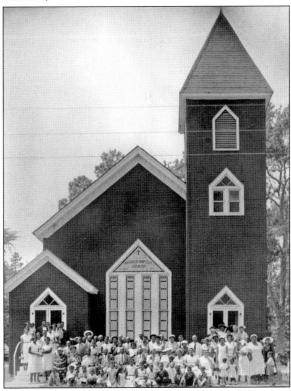

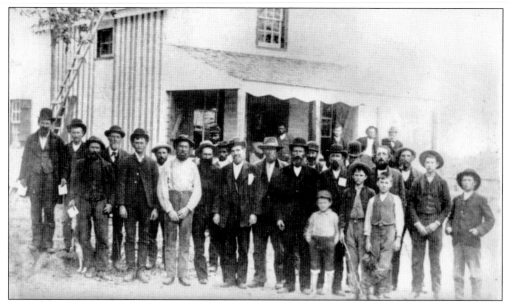

Gwynn's Island voters and others gathered for a photograph outside C. M. Hudgins's general merchandise store on Election Day 1875. Identified are, from left to right, Robert B. P. Hudgins, Lee Pickett, Ol' Blue (dog), Capt. Theodore Bentsen, Charles Hill, Allan Pickett, Noah Sterling, Dick Diggs, Robert Edwards, Dick Respess, John Carney, Washington Respess, Gilbert Crockett, Charles Collier, William H. Respess Sr., Carter Hudgins, Walter Grimstead, and William H. Respess Jr. The boys in front include Percy Simmons, Luther Owens, and Rufus Mariner. Two African Americans in the back row are Louis Griffin (tallest) and Dick McKnight. Standing on the porch in the rear are an unidentified black man, storekeeper Calvin Respess, a sturgeon roe buyer and a traveling merchant, and Charlie Brown in the plug hat behind the tallest boy. (Courtesy of the Gwynn's Island Museum.)

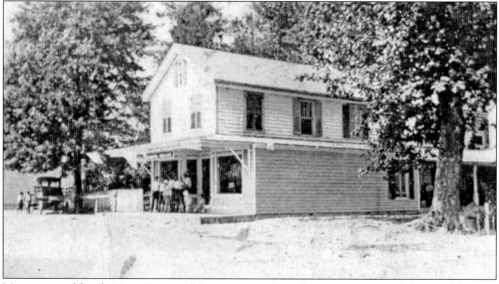

Many stores, like the Port Haywood Store seen in this photograph from Clifton M. Hudgins scrapbook, *Jolly Good Times in Mathews 1911–1951*, were a Saturday night gathering place for the men of the neighborhood. (Courtesy of the Gwynn's Island Museum.)

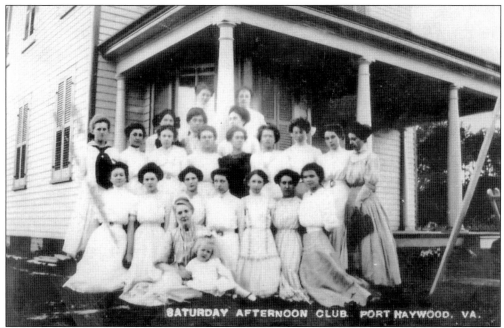

The Saturday Afternoon Club was held across the street from the store and post office in Port Haywood. Around 1900, women's clubs were often formed for social and political reasons. Often interracial, women discussed the urgent needs for workers' and women's rights and equality. (Courtesy of Catherine C. Brooks.)

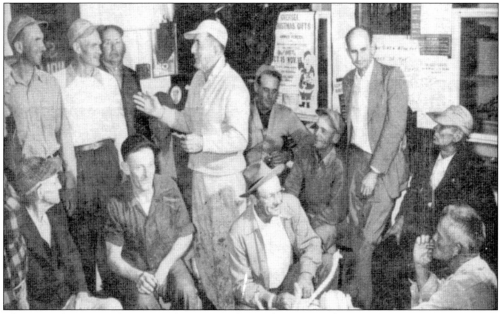

The general store run by Leonard R. "Scrooch" Callis was a gathering place for oystermen after a day's haul. Included in this photograph, discussing everything from oysters to politics, are George Fitchett, Logan Gay, Bob Hudgins, Gilbert Crockett, Leonard Buchanan, Aubrey Powell, "Scrooch" Callis, Ernest Callis, Georgie Buchanan, Jack Godsey, and Howard Jenkins. (Courtesy of the Gwynn's Island Museum.)

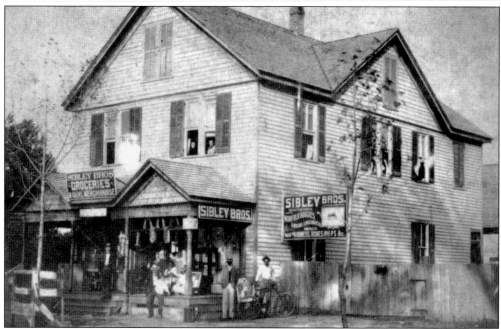

Sibley's General Store was built in 1898. The owners probably moved an older mercantile store from this prime location on Main Street in order to build the Victorian store. Thomas James, whose family moved to the area from the Eastern Shore, built the earlier store. It is believed that Mathews Court House was called Westville because people from Eastville on Virginia's Eastern Shore settled in the area. (Courtesy of Woody, Nancy, and Ron James.)

One hundred years earlier, the area was thriving and driven by the shipbuilding industry, but by 1900, Mathews was quiet. First tobacco then shipbuilding were profitable industries that had come and gone. Mathews also had been affected by disease and pillage related to two wars. This photograph of Main Street in Mathews Court House was taken around 1912. (Photograph by Herman Hollerith Jr.; courtesy of the Mathews County Historical Society.)

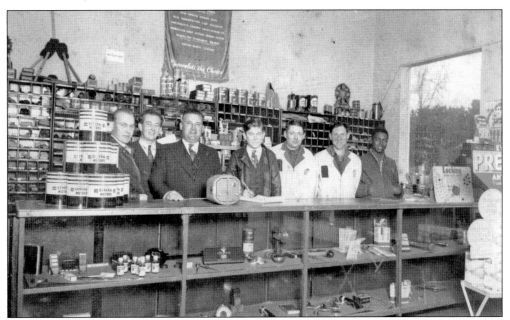

Motor vehicles brought the world to Mathews, and the world wars sent Mathews abroad. Twigg's Motors sold cars to those anxious to try them. In the 1920s, the *Mathews Journal* carried an announcement almost every time someone bought a car. Individuals identified working in the showroom and store include Bernard Anderton, J. Martin Diggs, and Pratt Twigg. (Courtesy of Ralph Anderton.)

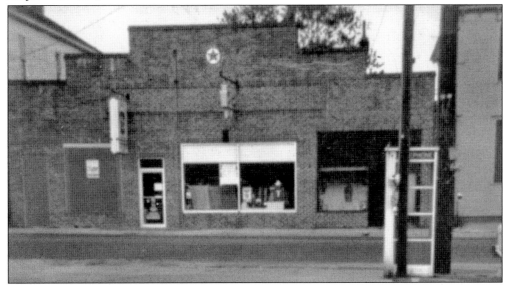

In the 1920s, George Philpotts built a Texaco garage with two pumps on Main Street. Clyde and Etta Fox ran the business while Philpotts ran the Mobjack franchise. The Mathews Court House Texaco closed during the Depression. Later, with the Be-Jo Theater operating nearby, Philpotts's property was enlarged and housed the Be-Jo Bowling Alley. During World War II, with many living away, the bowling alley closed. Since divided into sections, the building has housed a beauty parlor, Western Auto, Virginia Electric and Power Company, Bassett Furniture, the Craftsman Shop, and Dilly Dally Emporium. (Courtesy of Catherine C. Brooks.)

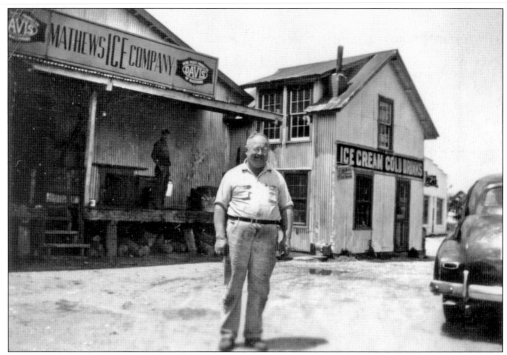

Generations of Mathews County citizens remember Hilton Green, pictured in this *c.* 1940 photograph taken in front of the Mathews ice plant. A March 3, 1927, article in the *Mathews Journal* records the founding of the ice cream operation: "A modern creamery and ice cream factory will surely be in operation in Mathews County by July 1, according to promoters of the enterprise who are canvassing the county this week. . . . The ice cream plant would be dependent on local product." (Courtesy of Catherine C. Brooks.)

In 1958, Ellis Hudgins and Herbert Gayle built the shopping center on Main Street in Mathews Court House that would include the A&P and, later, Barracks grocery stores, Western Auto, Gayles Furniture, and Mathews Post Office. It was torn down and rebuilt as a Food Lion store in 2001. (Courtesy of Catherine C. Brooks.)

In 1984, Rosanna Cooke (left) and Clarke Richardson posed for the *Gazette-Journal* reporter to promote the new expansion of Richardson's Drug Store, which created Rosie's Gift and Card Shop. (Courtesy of Tidewater Newspapers, Inc.)

During the 1983 Chamber of Commerce Candlelight Open House in Mathews Court House, Jessica Ball, daughter of Mr. and Mrs. Burley Ball Jr. of Diggs, told Santa her Christmas wishes. (Courtesy of Tidewater Newspapers, Inc.)

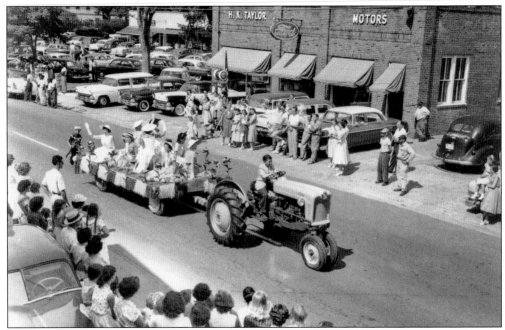

The Mathews Spring Festival was an annual mid-20th-century event. In 1955, a float carried Miss Mathews, Ann Shinault; the queen, Ellen Whitehead (Miss Virginia 1954); and princesses down Main Street. In addition to the parade, the Mathews Spring Festival included a coronation ceremony, the queen's ball, and boat races. (Courtesy of Tidewater Newspapers, Inc.)

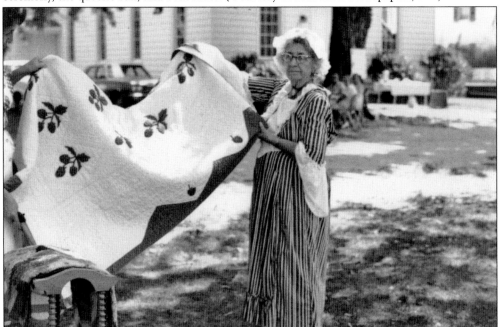

Mathews Market Days has been held on the Friday and Saturday following Labor Day since 1976, when the first celebration was held in honor of the nation's bicentennial. Citizens like Naomi Thompson, seen here dressed in Colonial costume, displayed crafts such as quilts and other handmade items. (Courtesy of Catherine C. Brooks.)

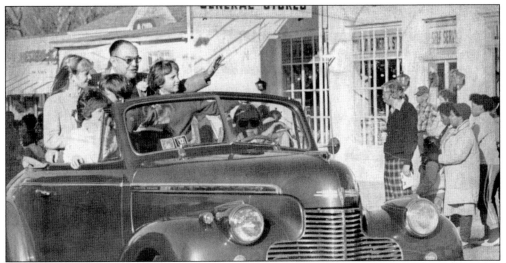

Dr. Richard B. Bowles, a Mathews physician from 1938 to 1987, was grand marshal of the Christmas parade in 1983. He was chauffeured in an antique automobile and accompanied by his five granddaughters. (Courtesy of Tidewater Newspapers, Inc.)

War veterans were featured in the 1991 Mathews Holiday Parade to celebrate the Persian Gulf War victory. Lester L. Smith of Susan, a veteran of World War I and retired banker was the "Great-Grand Marshal." The American Legion Post 83 and the Mathews Retired Officers Club formed a color guard. (Courtesy of Tidewater Newspapers, Inc.)

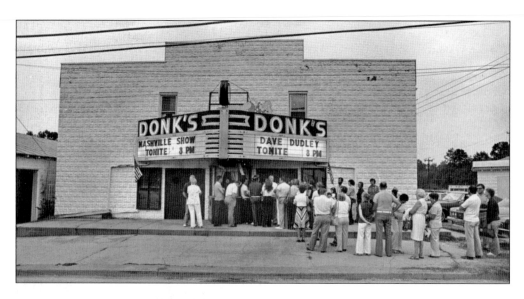

Wilton "Donk" and Mary Dunton built the grandest commercial building in Mathews. Donk's Theater opened in June 9, 1947, and attracted many to the movies as much for the upholstered seats, heating and air-conditioning, and sound system as for the show. The last movie was shown there on October 3, 1970. Jimmy Smith wrote in his "3rd Anniversary Program," "Donk's Theater . . . sat empty until a few of us decided to start Virginia's Lil Ole Opry, fashioned after the Grand Ole Opry." Family members Jimmy Smith, Harriet Ann Smith Farmer, Joanna Hudgins Mullis, and Betsy Hudgins Ripley formed a partnership to start the business, and the Smiths' first Country Jamboree was held in the old building on June 14, 1975. At bottom, Harriet stands in front of a display of country stars who have appeared at Donk's, including Dolly Parton, Ernest Tubb, and many more. (Both, photograph by Kenneth Silver; courtesy of the Smith family.)

"Daddy's Girl" Lynda Smith first sang before an audience at Donk's in 1976, when she was three. Smith went to Nashville and worked as a demo singer but decided to come home to Mathews instead of waiting to break into the big time. She currently sings regularly at Donk's and at other area venues. (Courtesy of Lynda Smith Greve.)

Picnics on the lawn are a cherished memory of growing up as a member of a large Mathews family. At this 1956 picnic celebrating the 40th wedding anniversary of Luther Seabrook Smith and Ruth Elizabeth Murden Smith, Jessie Lee (left) and Harriet Ann Smith, well known as the Singing Smith Sisters, serenaded the couple and guests. (Courtesy of Joice Smith Davis.)

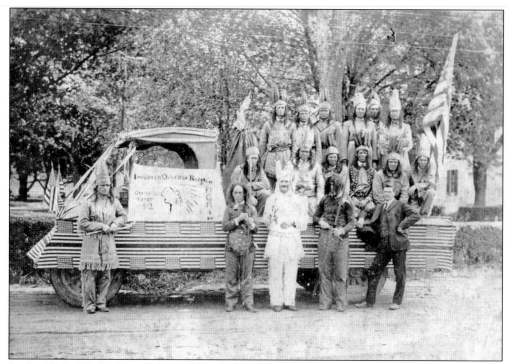

In the 1920s, Waylon Powell (seated fourth from left) posed before a parade with members of the Mathews Improved Order of the Red Men. The national fraternity traces its roots to the Revolution when members of a secret society, dressed as Mohawk Indians, dumped tea into Boston Harbor. Several patriotic groups throughout the United States joined together in 1834 to become the Improved Order of the Red Men. (Courtesy of Diana Hudgins Swenson.)

Strong community bonds were created by service in the military during two world wars. Members of the Virginia Reserve Militia in Mathews during World War II included, from left to right, (first row) Lt. Earl M. Hudgins, Capt. George E. Treakle, and Lt. Clyde Wilkins; (second row) unidentified, Sgt. Eugene F. Barnes, Vannie Armistead, Willie Brooks, Alfred Foster, Willie E. Owens, Ellis Respess, Wilbert T. Foster, unidentified, Sgt. Thomas M. Emory, and C. Eddie Forrest Jr.; (third row) R. Aubrey Tatterson, Richard D. Moger, company clerk Aubrey White, William B. Smith, and Floyd Earl Crewe. (Courtesy of Tidewater Newspapers, Inc.)

Seven

A RIVER PLACE

Through the 20th century and into the 21st, the popularity of a trip to the seashore or a place on the "rivah" has evolved. In the early 1900s, steamboats and then cars provided transportation for those seeking a pastoral vacation, far away from the city. In the early years, visitors stayed in homes where rooms could be rented. Individuals opened their homes as another means of income. Those who lived in Mathews in that early age would have been astonished by today's popular bed-and-breakfast trade.

In the 18th and 19th centuries, a visit to "take the waters" at a spa or seashore was considered to be good for the health. The steamboat line operators who offered round-trip excursion fares surely had this philosophy in mind when they offered the boat riding option. Even though with the rise of modern medicine, "taking the waters" was no longer believed to be a literal tonic, taking to the water, feeling the salty-smelling breeze, and pushing through the waves on the open bay surely had a positive effect on those who could enjoy it.

Those who motored or sailed to 20th-century Mathews might have enjoyed one of the Gwynn's Island hotels. Hotels have come and gone, but many people still want to stay at the shore. A Chesapeake beach house on Gywnn's Island or at Sand Bank suits those not excessively concerned about the chance of a hurricane. A piece of property tucked away in a cove on the East River might suit those looking for a quiet retirement lifestyle.

A trip to gaze at the river, bay, or ocean and feel the soft breeze offers spiritual relief. The lapping of waves and the call of gulls is the anti-alarm that teases us to get down and relax in the hammock, to think of nothing but perhaps a good book and plans for a seafood dinner.

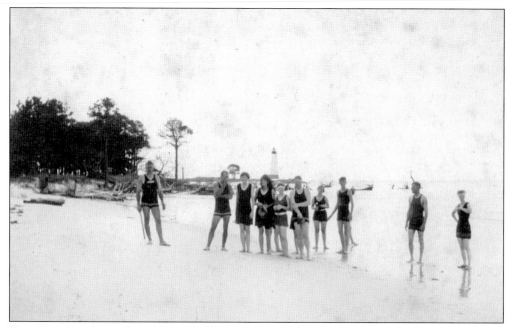

New Point Beach was famed far and wide. It was a popular spot for church picnics and yachting parties. This c. 1915 photograph captures a group of young people from the North River enjoying an outing to the New Point Comfort beach and lighthouse. The group of Tabb family relatives and friends had sailed from downriver and across the Mobjack for a day trip. (Courtesy William L. and Martha Ellen Brockner.)

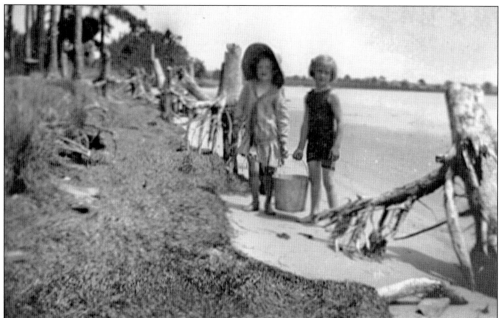

Children in bathing costumes carry a bucket for collecting shells and other treasures on the beach at Poplar Grove. In this 1909 photograph, a thick blanket of seaweed has been pushed up on the shore by the tide. (Photograph by Herman Hollerith Jr.; courtesy of the Mathews County Historical Society.)

One boy paddles a small skiff while another sits in the bow and two others hold on and look past their feet to see what they can see in the creek. (Photograph by Herman Hollerith Jr.; courtesy of the Mathews County Historical Society.)

Visitors to Mathews enjoy taking a ride on Capt. Ben Foster's bugeye, the *Alexander Bond*. (Photograph by Herman Hollerith Jr.; courtesy of the Mathews County Historical Society.)

The Gwynn's Island Hotel, owned by Capt. and Mrs. David Hodges of Gwynn, was about 100 years old when it was destroyed by fire. The three-story hotel had 21 rooms and was located on North Bay Haven Drive near the shore of the Chesapeake Bay. Later a motel was built on the Hills Bay side of the Gwynn's Island Bridge with a marina and restaurant. It went out of business around 2000. (Courtesy of the Gwynn's Island Museum.)

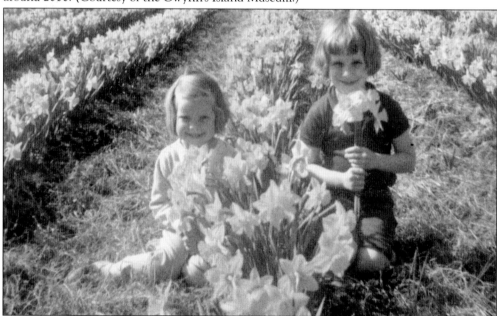

Nancy James remembers picking daffodils at her Edwards family's farm in Dixie. Daffodils were shipped from Gloucester and Mathews from the late 19th century until the mid-20th century. Tourists still come to the area when daffodils bloom to see the golden fields and to visit old homes and gardens during Virginia's Historic Garden Week. (Courtesy of Woody, Nancy, and Ron James.)

Visitors in the 1940s to Richardson's Drugstore on Main Street in Mathews Court House could pick up this brochure to learn more about things to see and places to go in Mathews. (Courtesy of Ralph Anderton.)

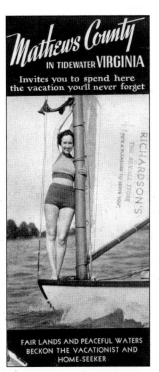

The brochure included pictures of the Mathews Court House area and billed it as "The center of a happy and prosperous community." (Courtesy of Ralph Anderton.)

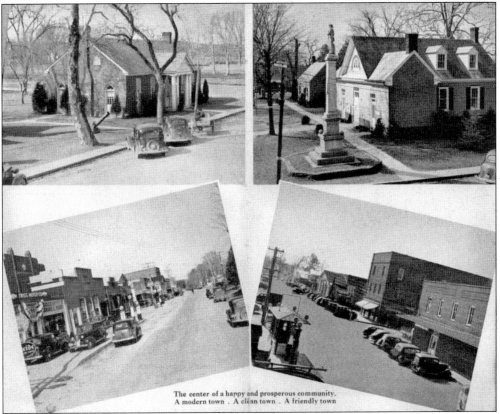

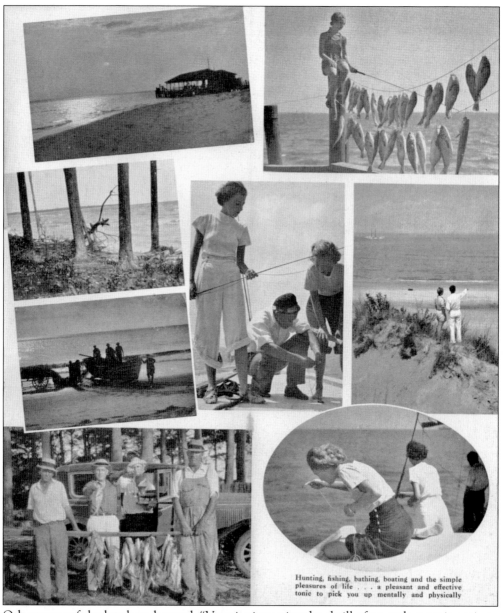

Hunting, fishing, bathing, boating and the simple pleasures of life . . . a pleasant and effective tonic to pick you up mentally and physically

Other pages of the brochure boasted, "Vacationists enjoy the thrill of an early-morning trip to the fishing grounds in Chesapeake Bay . . . Hunting, fishing, bathing, boating, and the simple pleasures of life . . . a pleasant and effective tonic to pick you up mentally and physically. . . . Tranquil rivers and creeks and sunny beaches beckon the tired businessman and his family, . . . [and] A friendly climate and productive soil make life pleasant for the farmer." (Courtesy of Ralph Anderton.)

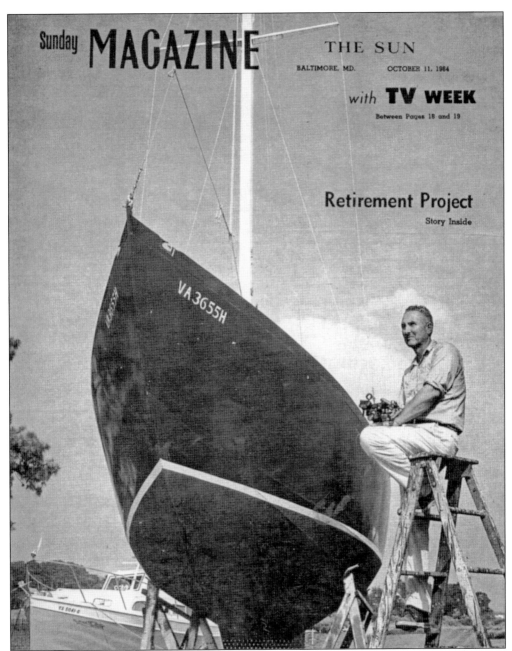

Sunday MAGAZINE

THE SUN

BALTIMORE, MD. OCTOBER 11, 1964

with **TV WEEK**

Between Pages 18 and 19

Retirement Project

Story Inside

VA 3655H

Gilbert Klingel (1908–1983) was a businessman, author, and naturalist. He is perhaps best known for his book *The Bay*, originally published in 1951. In it, he examines the complex ecological balance of the Chesapeake Bay. His writing has been described as spellbinding. He retired to Gwynn's Island in 1963 and tried his hand at boatbuilding. His writings about this attracted visitors to Mathews, and he was always willing to speak with them. Learn more about Klingel by visiting the Gwynn's Island Museum. (Courtesy of the Gwynn's Island Museum.)

Special events bring visitors to Mathews. One thousand cyclists participated in the Fifth Annual Tour de Chesapeake. Martha Foster (right), a member of the Continental Society, was on hand to serve muffins and coffee. The Continental Society, Piankatank Ruritan Club, and Mathews Kiwanis prepared and sold food to bicyclists and worked with the chamber of commerce on the project. Some visitors camped at Mathews High School while others stayed at New Point Campground, area motels, bed-and-breakfasts, and private homes. (Both, courtesy of Tidewater Newspapers, Inc.)

Eight

CHALLENGES AHEAD

Mathews is a proud and beautiful county that delights "been-heres," "come-heres," "come-backs," and just-visiting visitors. Rolling down Route 14 or Route 198, passing over the impression of a long-ago crater rim, and entering a flat landscape, almost level with the water—all who come feel the magic of a place that sometimes looks like the land that time forgot.

What could be better?

At the same time, there is real concern. Everywhere in Mathews there is talk about erosion. This region with no natural rock now has boulders armoring its shore all around. Use of rock accelerated after Hurricane Isabel in 2003. Before then, the August storm of 1933 was the paradigm of destruction. Even though the tides during the storms were very similar, the amount of surge was different. The 1933 storm produced a storm surge that was greater than Isabel's by slightly more than a foot. However, an analysis of water levels in August 1933 and September 2003 showed that sea level had risen by 1.35 feet in the 70 years between these two storms. This explains why water levels were as high or higher during Hurricane Isabel than they were during the 1933 storm.

Scientists say that half of the sea level rise is due to subsidence, or sinking of the land, and the other half can be attributed to a worldwide rise in sea level. Together, these two forces are having a large impact on Mathews and the entire Virginia coastline. As the sea level continues to rise, coastal flooding is moving farther inland, especially where natural barriers such as oyster reefs, sea grasses, sand dunes, and forests no longer exist.

Our challenge is not to let our contentment cloud our resolve to do the things that we can to prevent erosive runoff and restore natural edges that acknowledge Mother Nature's will and strength.

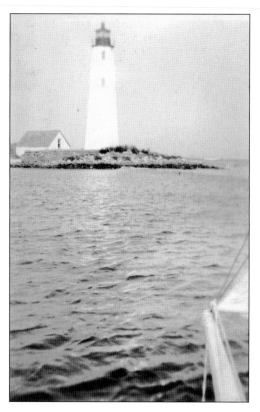

New Point Comfort Lighthouse was built on a point of land that jutted out from the tip of Mathews into the Chesapeake Bay. One hundred years ago, as seen at top, it sat comfortably on the sand with a yard and outbuilding. But the sandy shore was fractured and broken by repeated severe storms. The August storm of 1933 was able to cut a wide swath that separated the lighthouse and a section of beach from the mainland. The island was accessible only by boat. Today there is no sandy beach. The lighthouse is fortified against tide and storm by an island of stones piled around the tower, as seen at the bottom in a photograph taken from inside and through the lighthouse window. Boulders fortify the sandstone tower in the place where it has stood for 200 years. Ironically aligned against the will of the Chesapeake Bay, it remains a strong symbol of Mathews history and the connection of her people to the sea. (Top, courtesy of William L. and Martha Ellen Brockner. Bottom, courtesy of Woody, Nancy, and Ron James.)

BIBLIOGRAPHY

Brooks, Catherine C. *Didn't Know We Were Poor.* West Conshohocken, PA: Infinity Publishing.com, 2007.
———. *Walk with Me.* West Conshohocken, PA: Infinity Publishing.com, 2005.
Chamberlayne, C. G. *The Vestry Book of Kingston Parish, 1679–1796.* Richmond, VA: Old Dominion Press, 1929.
Dixon, John W. *Gwynn's Island: A Brief History of the Oldest Permanent English Settlement on a Middle Peninsula of Virginia.* Gwynn's Island, VA: Gwynn's Island Museum, 2004.
Edwards, Henry Gwynn. *Memories from Mill Point: The Autobiography of Henry Quinn Edwards.* Gwynn's Island, VA: Gwynn's Island Museum, 2000.
Evergreen, May. *Chimes from the Chesapeake.* Gwynn's Island, VA: Gwynn's Island Museum, 2000.
Klingel, Gilbert. *The Bay.* Baltimore, MD: Johns Hopkins University Press, 1951; reprint 1984.
Mathews County Historical Society. *Mathews County Panorama: A Pictorial History of Mathews County 1791–1941.* Mathews, VA: Mathews County Historical Society, Inc., 1983; reprint 2000.
———. *History and Progress, Mathews County, Virginia.* Mathews, VA: Mathews County Historical Society, 1982; reprint 1988.
Moore, Gazelle "Tootie." *Reminiscences: The Old Stores of Gwynn's Island.* Gwynn's Island, VA: Gwynn's Island Museum, 2001.
Powell, William Hobson. *Growing Up on Gwynn's Island.* Gwynn's Island, VA: Gwynn's Island Museum, 2000.
Ryan, David D. *Gwynn's Island, Virginia: Stories of a New World Settlement from the First Families to the Present.* Richmond, VA: The Dietz Press, 2000 and 2004.
Tanner, Bob and Jean, eds. *Gwynn's Island and the Great Storm of 1933 and Other Weather Related Accounts.* Gwynn's Island, VA: Gwynn's Island Museum, 2002.
Verbyla, Elsa Cooke, ed. *Gwynn's Island Times: News Items 1905–1950,* Gloucester, VA: Tidewater Newspapers, Inc., 1998.
Wrike, Peter Jennings. *The Governor's Island: Gwynn's Island, Virginia during the Revolution.* White Stone, VA: Brandylane Publishers, 1993.

ACROSS AMERICA, PEOPLE ARE DISCOVERING SOMETHING WONDERFUL. *THEIR HERITAGE.*

Arcadia Publishing is the leading local history publisher in the United States. With more than 4,000 titles in print and hundreds of new titles released every year, Arcadia has extensive specialized experience chronicling the history of communities and celebrating America's hidden stories, bringing to life the people, places, and events from the past. To discover the history of other communities across the nation, please visit:

www.arcadiapublishing.com

Customized search tools allow you to find regional history books about the town where you grew up, the cities where your friends and family live, the town where your parents met, or even that retirement spot you've been dreaming about.